TASCHEN *est.1980*

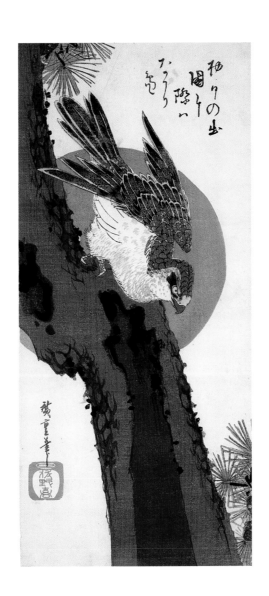

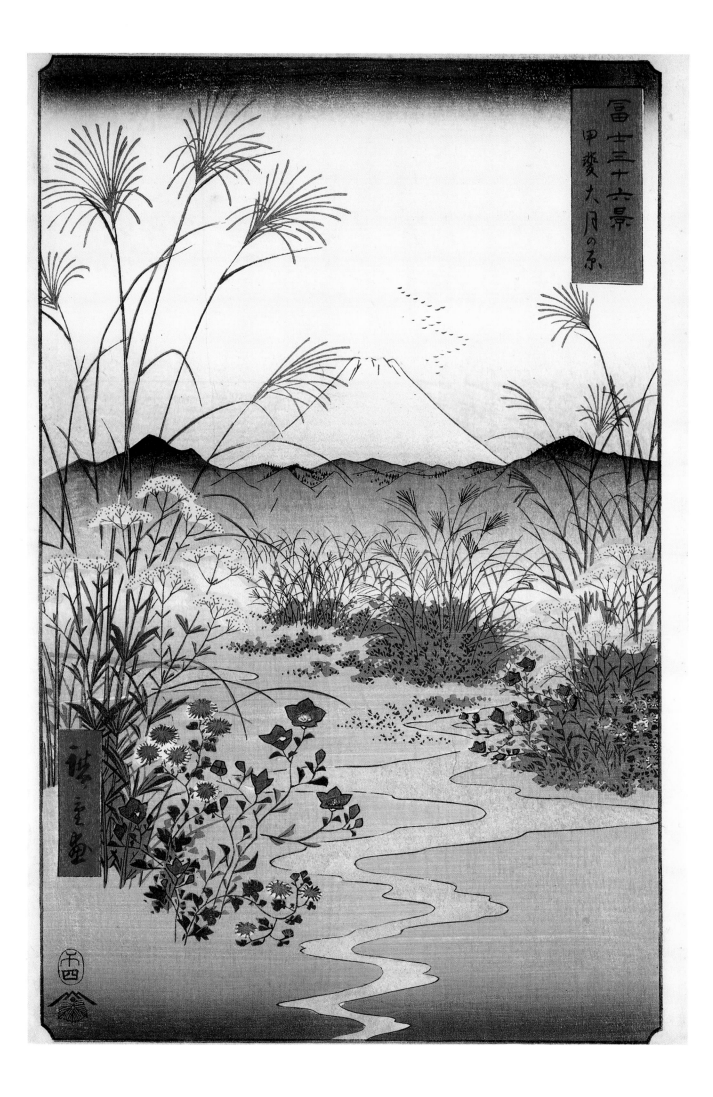

Adele Schlombs

Hiroshige

1797–1858

Master of Japanese
Ukiyo-e Woodblock Prints

Chazen Museum of Art, Van Vleck Collection of Japanese Prints,
University of Wisconsin-Madison

TASCHEN

PAGE 1:
Falcon on a Pine with the Rising Sun
Published by Sanoya Kihei, c. 1832
Polychrome print, ōtanzaku, 37.1 x 16.8 cm (15.4 x 23.2 in.)

PAGE 2:
Ōtsukigahara Plain in Kai Province
From the series "36 Views of Mount Fuji"
(*Fuji sanjūrokkei*), published by Tsutaya Kichizō, 1858
Colour print, ōban, 34 x 22.4 cm (13.4 x 8.8 in.),
top and bottom borders cut off

Standard Formats of Japanese Prints

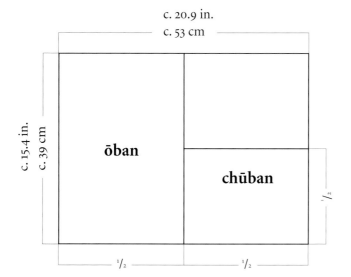

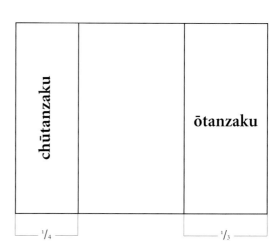

To stay informed about upcoming TASCHEN titles, please request
our magazine at www.taschen.com/magazine or write to
TASCHEN America, 6671 Sunset Boulevard, Suite 1508, USA-Los Angeles, CA 90028,
contact-us@taschen.com, Fax: +1-323-463.4442.
We will be happy to send you a free copy of our magazine
which is filled with information about all of our books.

© 2010 TASCHEN GmbH
Hohenzollernring 53, D–50672 Köln
www.taschen.com
Original edition: © 2007 TASCHEN GmbH
Translation: Michael Scuffil, Leverkusen
Project coordination: Petra Lamers-Schütze
Layout and editorial coordination: Daniela Kumor, Cologne
Cover design: Sense/Net Art Direction,
Andy Disl and Birgit Eichwede, Cologne, www.sense-net.net

Printed in China
ISBN 978-3-8365-2358-5

Contents

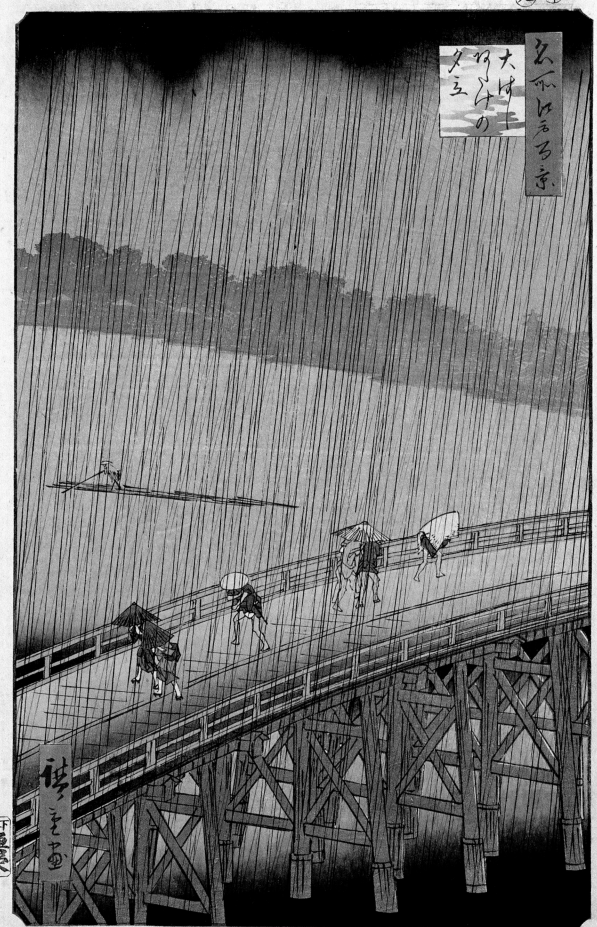

The Landscape Woodblock Print – A New Look at Reality

With the appearance of Hokusai's "36 Views of Mount Fuji" in 1830 and Hiroshige's "53 Stations of the Tokaidō" between 1832 and 1834 the landscape conquered the Japanese ukiyo-e woodblock print more or less overnight. The term *ukiyo-e* means, literally, "pictures of the floating transitory world". It is derived originally from the Buddhist idea of the illusory and futile character of worldly existence. During the Edo period, the term however took on a hedonistic flavour, and was linked with the pleasurable amusements of the urban population in the tea-houses and brothels, in the Kabuki theatre and the sumo wrestling arenas. In view of the shortness and inconstancy of life, the motto was: drift along, enjoy the moment, and address all the senses to transient pleasures. So we read, tellingly, in a novel by Asai Ryoi published in 1661 under the title *Story of the Floating World* (*Ukiyo monogatari*): "Live for the moment, look at the moon, the cherry-blossom and maple leaves, love wine, women and poetry, encounter with humour the poverty that stares you in the face and don't be discouraged by it, let yourself be carried along on the river of life like a calabash that drifts downstream, that is what *ukiyo* means."

Until the 1830s the landscape served above all as a backdrop in prints of beautiful women and in the portraits of actors and heroes; it was there to lend credibility to the narrative content of the depiction of the protagonists. Now, though, the landscape emancipated itself from the context of figure depiction, and became the theme of the picture in its own right. In the works of Hokusai (p. 41) and Hiroshige, who put their unmistakable personal stamp on the landscape depictions of the 19th century, it was suddenly the figures that had to find their place in the views of nature. In this process Hiroshige was concerned chiefly with the subjective depiction of reality, which he exaggerated by an unconventional choice of perspective and "cropping" and by the use of colour to reproduce atmospheric light and weather conditions, subjecting them to a personal interpretation. The result was cityscapes, and depictions of travel-routes and the famous sights in the four seasons, in which he confronted the viewer not only with the anonymity of the city dweller and the drudgery of the working population, but also with the involuntarily comic aspects of their activities, which he observed with a wide-awake, often satirical humour, but never with cynicism.

The starting point – or the end, depending on point of view – of the two highways linking Edo with Kyoto was the Nihonbashi Bridge (p. 8). Hiroshige

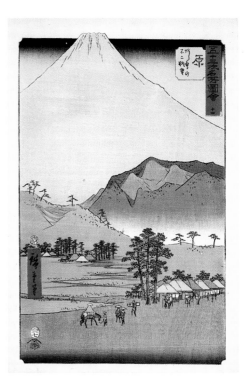

Mount Fuji and Mount Ashitaka Viewed from Hara Station
From the series "Famous Views of the 53 Stations" (*Gojūsantsugi meisho zue*) in vertical format, published by Tsutaya Kichizō, 1855
Colour print, ōban, 34.3 x 22.6 cm (13.5 x 8.9 in.), border preserved

Sudden Shower over the Ōhashi Bridge near Atake
From the series "100 Famous Views of Edo" (*Meisho Edo hyakkei*), published by Uoya Eikichi, 1857
Colour print, ōban, 37.4 x 25.6 cm (14.7 x 10.1 in.), border preserved

shows it in early morning light in his first series of the "53 Stations of the Tokai-dō", dating from 1832 to 1834. This arched wooden bridge had been built by the military government in 1602. It became a major traffic junction, with shops, warehouses, fish-markets and houses lining the banks of the river. The wooden gate has been opened for the early morning traffic. The procession of a feudal lord, setting out for his fief, stands out against the clear orange horizon. The procession is led by two porters, bent forwards, carrying clothes trunks on poles on their shoulders; they are followed by standard bearers. In the foreground fishmongers are returning from the market with full baskets on their shoulders, while on the right, a humorously ironic note is struck by the chance encounter of two stray dogs. The composition, with its central perspective, lends the scene reality, but at the same time a sober and energy-charged atmosphere is created by the glowing red horizon interacting with the working people, who are depicted as types, not as individuals or characters.

The atmosphere in the depiction of the ferry on the Yodo River, which plied between Kyoto and Osaka, is quite different. This print is part of the series "Famous Views of Kyoto" (*Kyōto meisho no uchi*) and likewise dates from the time around 1834 (p. 9). It shows people returning exhausted from work by the light of the moon. They have hung their sun-hats on the ridge of their simple straw shelters. A small boat is fastened to the ferry with a rope; in it, a meal is being prepared. Some travellers are bent over their food bowls, while others are dozing or sleeping; one woman is breast feeding her infant. The faces are shapeless, and barely distinguishable. The boats jutting into the composition diagon-

The Nihonbashi Bridge at Daybreak
The 1st station of the series "53 Stations of the Tokaidō" (*Tōkaidō gojūsantsugi*), published by Hōeidō (Takenouchi Magohachi) and Senka-kudō (Tsuruya Kiemon), 1832 or 1833
Colour print, ōban, 22.6 x 34.3 cm (8.9 x 13.5 in.), border cut off

Hustle and bustle on the Nihonbashi Bridge in the early morning: fishmongers are returning from the market and the procession of a feudal lord (*daimyō*), led by porters, is clearing a path. Not only the shape of the clouds, but also the shading of the gate and its posts, demonstrate that Hiroshige was familiar with Western copperplate engravings.

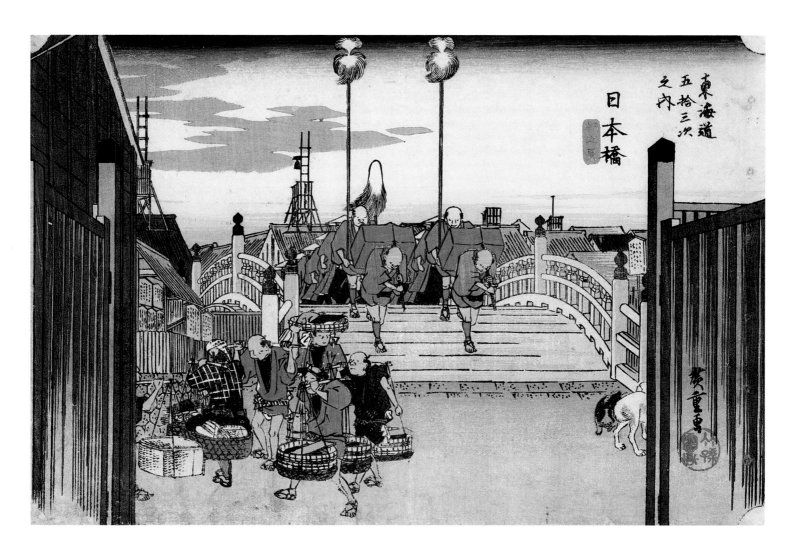

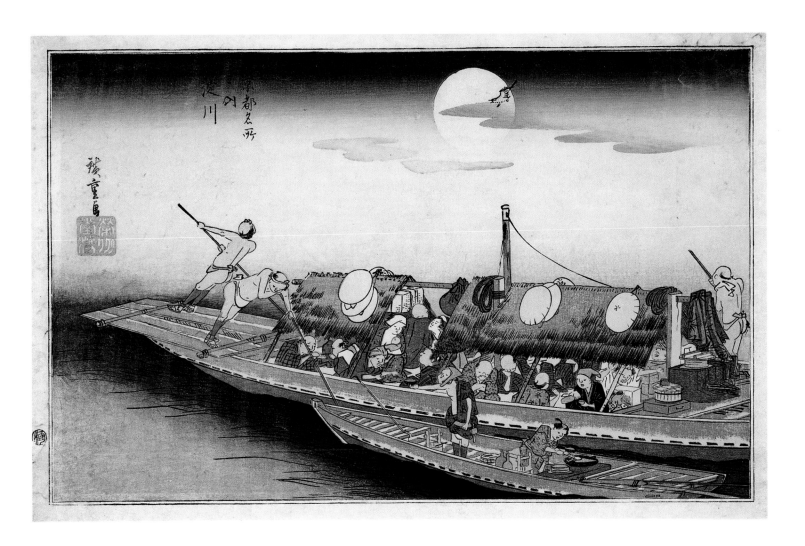

ally from the lower right convey an impression of heaviness, which accords with the fatigue of the occupants. The cuckoo standing out against the full moon seems to have been noticed only by the boatmen.

The print of the Mie River near Yokkaichi (pp. 10–11), also from the series "53 Stations of the Tokaidō", shows a heavily laden man trying to retrieve his hat, which has been blown away by the wind. The road, projecting diagonally into the picture, is continued by a wooden bridge, over which a man with a billowing cloak is going his way. The willow and the reeds are also bending dramatically in the wind. Only the roofs and masts hinted at in the background convey an impression of calm. The composition, with a man in the middle distance walking out of the picture with his back turned to the viewer, and in the foreground a man running diagonally out of the picture, humorously sums up the apparent arbitrariness of the situation.

The Seki station (p. 13) in the Reisho series "53 Stations of the Tokaidō" (c. 1848) is one of Hiroshige's popular snowscapes and depicts homecoming farmers in falling snow on the road to the Ise shrine shortly before nightfall. On the steep slope stands a snow-covered gate (torii), which marks the way to the Shinto shrine. Carefully the people are moving through the snow; it is as if we can almost hear the silence.

How did this new way of seeing things arise? And how can it be explained that landscape prints like this suddenly found such an echo and demand among country people and city dwellers who could not afford expensive paintings and thus preferred cheap prints? To attribute this development solely to a tightening of the censorship laws, by which the military government sought to ban im-

The Yodo River
From the series "Famous Views of Kyoto" (*Kyōto meisho no uchi*), published by Eisendō (Kawaguchi Shōzō), c. 1834
Colour print, ōban, 22.2 x 35.5 cm (8.7 x 14 in.), border preserved

By the light of the full moon, people are taking the evening ferry home, tired out after their day's work in Ōsaka.

PAGES 10–11:
The Mie River near the Yokkaichi Station
The 44th station of the series "53 Stations of the Tokaidō" (*Tōkaidō gojūsantsugi*), published by Hōeidō (Takenouchi Magohachi), 1833/34
Colour print, ōban, 22.7 x 35 cm (8.9 x 13.8 in.), border preserved

A violent whirlwind is scattering the elements of the picture in all directions. The composition is multifocal and has no centre, a means used by Hiroshige to draw the viewer into the chaotic scene.

9

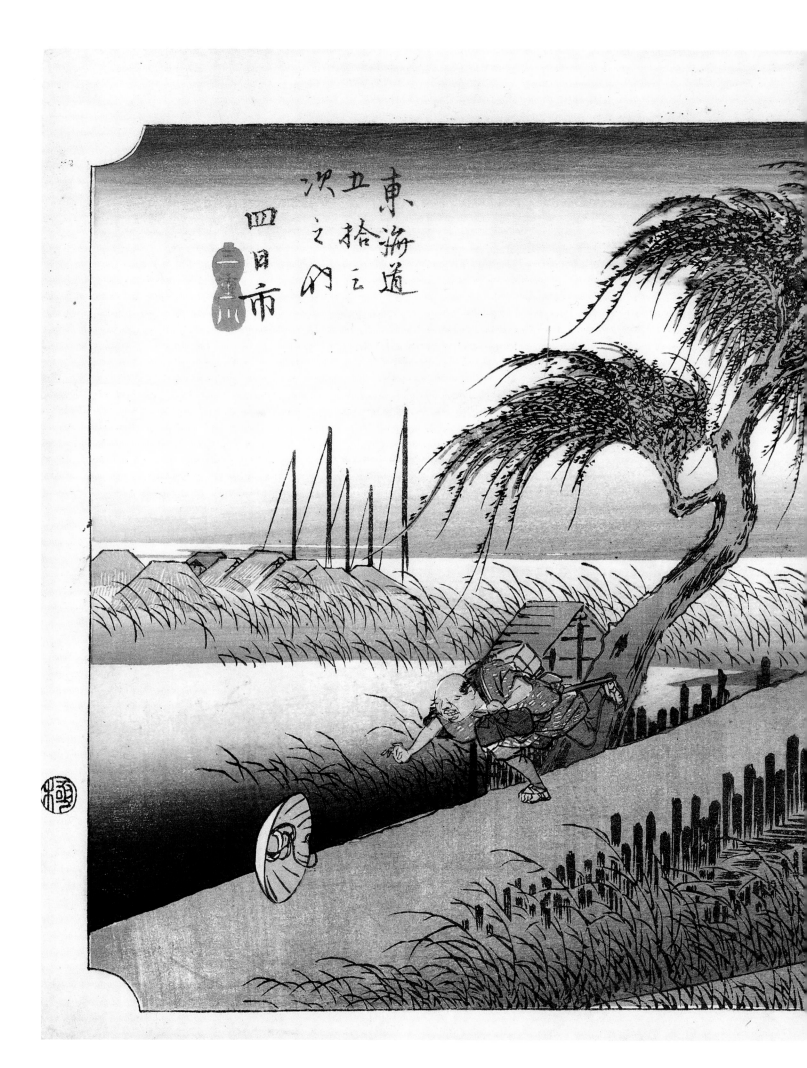

10

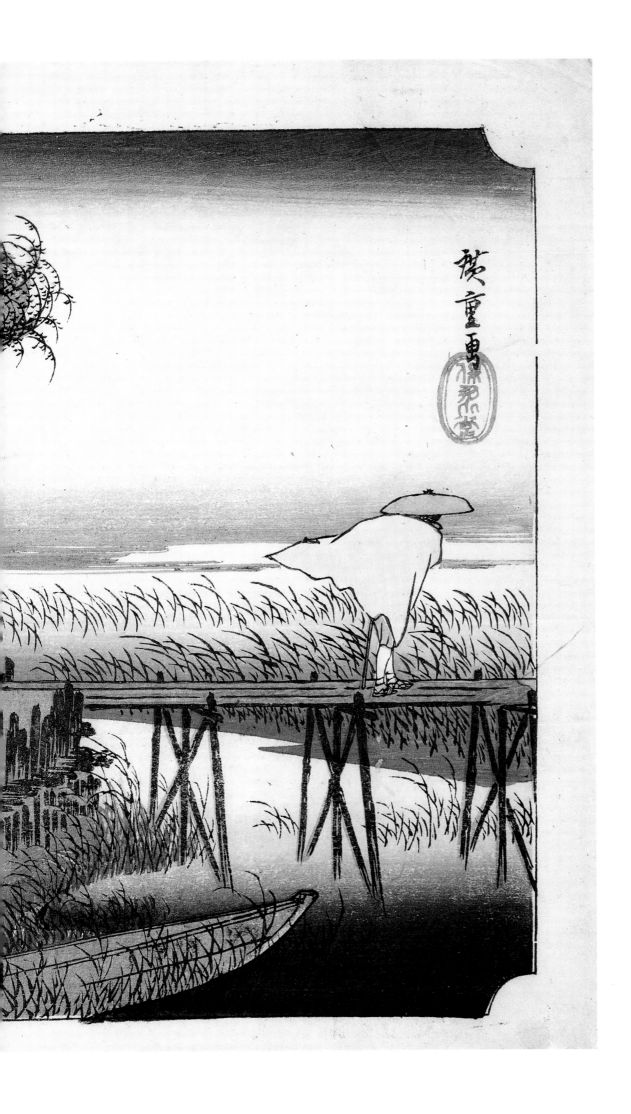

Mount Fuji and Mount Ashigara Viewed from Numazu Station in Clearing Weather Following a Snowfall
From the series "Famous Views of the 53 Stations" (*Gojūsantsugi meisho zue*) in vertical format, published by Tsutaya Kichizō, 1855
Colour print, ōban, 34.3 x 22.6 cm (13.5 x 8.9 in.), border preserved

Snow near Yamanaka
From the series "Famous Views of the 53 Stations" (*Gojūsantsugi meisho zue*) in vertical format, published by Tsutaya Kichizō, 1855
Colour print, ōban, 34.3 x 22.6 cm (13.5 x 8.9 in.), border preserved

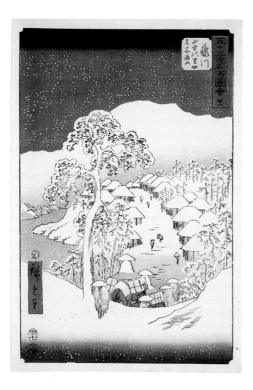

moral brothel motifs as well as luxuriously produced ukiyo-e prints, would be too narrow. And to explain it by the comet-like appearance of two landscape geniuses would be equally unconvincing.

The time was ripe for the landscape print. In his landscape and travel depictions, Hiroshige expressed feelings and moods which struck a chord with the mass of the people. Quite literally, his series "53 Stations of the Tokaidō" documents the appropriation by the people of the native Japanese landscape. At least on the plane of emotional expression and artistic means, this term seems legitimate. For the subject of the *meisho*, the "famous views" of places of pilgrimage and spectacular natural phenomena, of river crossings and mountain ascents, had a long tradition in the idealizing paintings of the classical painting schools, whose works, executed on screens and sliding doors, decorated the prestigious villas of the feudal and court nobility. By contrast, Hiroshige as a rule idealized neither the landscape nor the people who populated it. He translated the *meisho* theme into the language of the popular print and thus gave expression to the confident claim of the people to their own native landscape. At the same time, this heralded the downfall of an inflexible feudal system that had long since ceased to reflect the social reality.

Unfortunately we know little about Hiroshige's personal life. The few indications that we do have produce a sketchy picture that hardly allows any conclusions relating to his thought or artistic goals. For this reason we cannot say for certain to what extent he was aware of his pioneering role, or of the political and social dimension of his œuvre. In order better to understand the political context of his work, we need first to take a look at the general political and social conditions of his age. Otherwise it is Hiroshige's work itself that reveals his personality and his artistic intention.

After a century and a half of bloody power struggles between the feudal lords, which had tragically involved the whole population, Toyotomi Hideyoshi put down the feudal rulers and in 1615 a centralization of power was finally achieved by Tokugawa Ieyasu (1542–1616), the founder of the military regime that bears his name and which was to last for almost 250 years. Ieyasu divided the country into some 200 territories, each ruled by a feudal lord, and transferred the centre of power from the flourishing city of Kyoto to Edo, today's Tokyo, which is why the Tokugawa period (1615–1668) is also known as the Edo period. By having himself proclaimed the quasi-divine protector of the country, he made the Emperor, who continued to reside in Kyoto, the accomplice in his claim to sole power.

The economic upturn of the 16th century was based on maritime trade with the Spanish and Portuguese and the export of large quantities of silver, which was exchanged for gold. But the Portuguese, who first landed in Japan in 1543, were accompanied by the first Jesuit missionaries and the first firearms, on which the military successes of the feudal lords (*daimyō*) depended. In order to disempower the feudal nobility, Japanese Christians were subjected to drastic persecution, and all private trade was banned. To this end, in 1639 the Tokugawa government closed all the country's ports, with the exception of Nagasaki, where Chinese ships docked: the artificial island of Dejima in the harbour provided a sealed off and easily monitored venue for the Dutch trading post. Nagasaki thus formed Japan's only gateway to the world. This isolation was to last until 1853, when the American commodore Matthew Perry (1794–1858) landed in Tokyo Bay and forced the government to open the country to American commercial shipping. This forced opening-up of Japan was one of the most decisive events

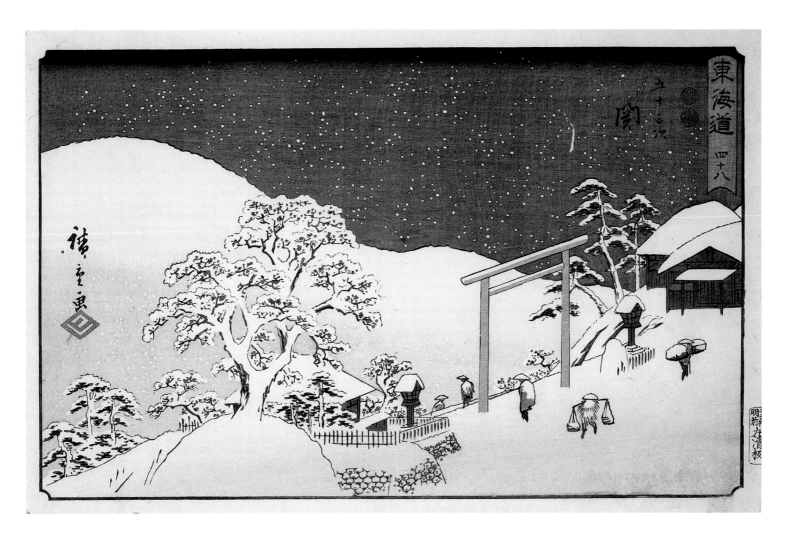

of the 19th century, for it led ultimately to the downfall of the decaying military government and to the restoration of the Emperor, who in the Meiji period (1868–1912) was to pursue the reform of Japan on the Western model.

As vassals, the *daimyō* owed the shogun absolute loyalty. While they were allowed to administer their fiefs themselves and also deploy the warriors subordinate to them (samurai) to keep order, they were themselves subject to constant monitoring by the military government. Thus every *daimyō* was required to leave his wife and children as hostages in Edo and to maintain a fitting residence there at his own expense. The military government also required the lords to spend every second year in Edo, which was attended by expensive journeys, and was designed to deprive them of any possibility of forming alliances with other lords or forging local conspiracies.

Seki
The 48th station of the series "53 Stations of the Tokaidō" (*Tōkaidō gojūsantsugi*), published by Marusei (Maruya Seijirō), Reisho edition, c. 1848
Colour print, ōban, 22 x 34.8 cm (8.7 x 13.7 in.), border preserved

Hiroshige has reproduced the atmosphere of the village and its Ise shrine in masterly fashion as they lie submerged in snowdrifts. Shortly before the onset of dusk, people proceed cautiously down the mountainside into the valley, whose spatial depth is suggested at by a delicate blue shading.

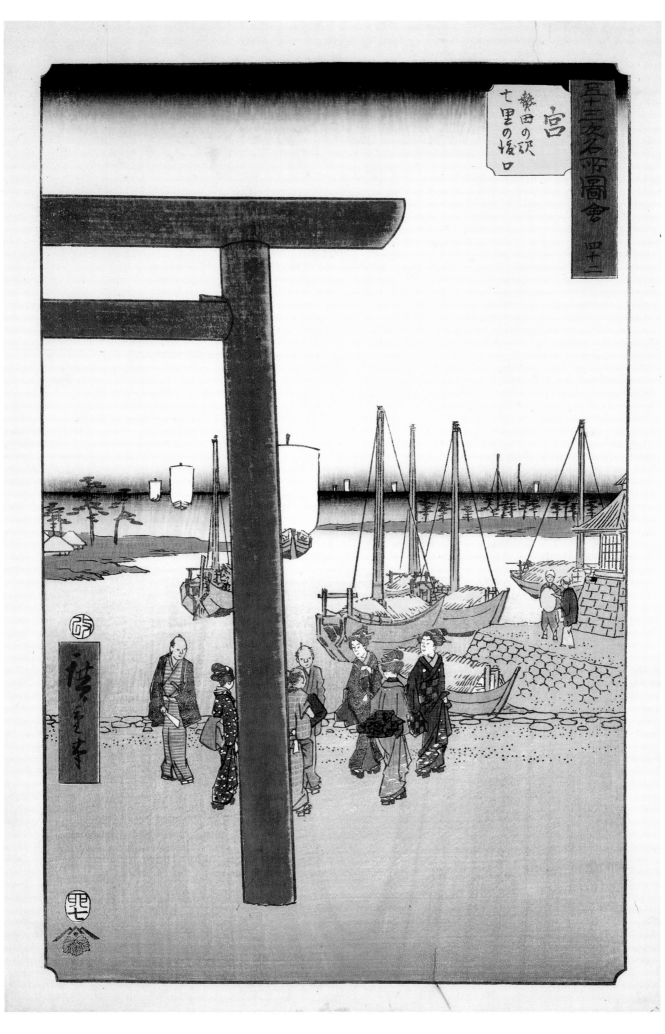

Routes and Destinations

Country dwellers and townspeople alike had many opportunities to watch the spectacle of the elaborate processions of the *daimyō* with their retinues of up to 3,000 (p. 8). They would either be on their way to the shogun in Edo, or on their way back to their fiefs for a limited period. In his first series of "53 Stations of the Tokaidō", Hiroshige depicts for example the procession of a *daimyō* descending the menacingly grey-coloured valley of the Hakone Pass to Lake Ashi on the stretch between Odawara and Mishima (pp. 16–17). We have a bird's-eye view of the headgear of the porters as they push along a narrow path on the steep slope, seeming to merge into the barren mountain backdrop made up of patches of grey, brown, blue, green and beige.

In order to facilitate its control of the *daimyō* and get proclamations and laws by messenger to their recipients as quickly as possible, the military government promoted the improvement of roads, but not bridges, as these could have favoured the spread of rebellion. The most important highways were the Eastern Sea Road, or Tokaidō, along the Pacific coast, and the mountainous inland route or Kisokaidō, both of which linked Edo with the imperial city of Kyoto. The distance from Edo to Kyoto via the Eastern Sea Road was about 500 kilometres. Depending on the weather, travellers on foot needed 10 to 16 days to cover this distance. Mounted couriers took from 50 and 60 hours, while runners needed about six days. Hiroshige depicted the 53 stations on the Tokaidō in numerous woodcut series that appeared at various dates, and thus immortalized its fame.

While users had to adhere to many formalities and were subjected to frequent identity checks, these highways were open to merchants, travelling craftsmen, private travellers, pious pilgrims and those who sought adventure under the pretext of undertaking a pilgrimage. In the second half of the 18th century and during the 19th, the Japanese love of pilgrimages took on hitherto undreamt-of dimensions, a development that was to play a key role in the success of landscape prints. They went to famous temples, Shinto shrines, and holy mountains, as this was the only legitimate form of holiday available to ordinary people. Thus associations (*kō*) were formed in villages and town districts to collect money for the pilgrimage to particular shrines. A number of winners were chosen by lot; they would undertake the expensive pilgrimage as representatives of the whole association.

Balustrade Post on Nihonbashi Bridge, Woman at Night with a Lantern in Shinagawa, Souvenirs of the Kawasaki Daishi Temple and Craft Products from Ōmori, View of Yokohama in Kanagawa
From the series "Harimaze Pictures of the Tokaidō" (*Tōkaidō harimaze zue*), published by Izumiya Ichibei, 1852
Colour print, ōban, 33.6 x 23.2 cm (13.2 x 9.1 in.), border preserved

The Shichiri Ferry Landing near Atsuta, Miya Station
From the series "Famous Views of the 53 Stations" (*Gojūsantsugi meisho zue*) in vertical format, published by Tsutaya Kichizō, 1855
Colour print, ōban, 34.3 x 22.6 cm (13.5 x 8.9 in.), border preserved

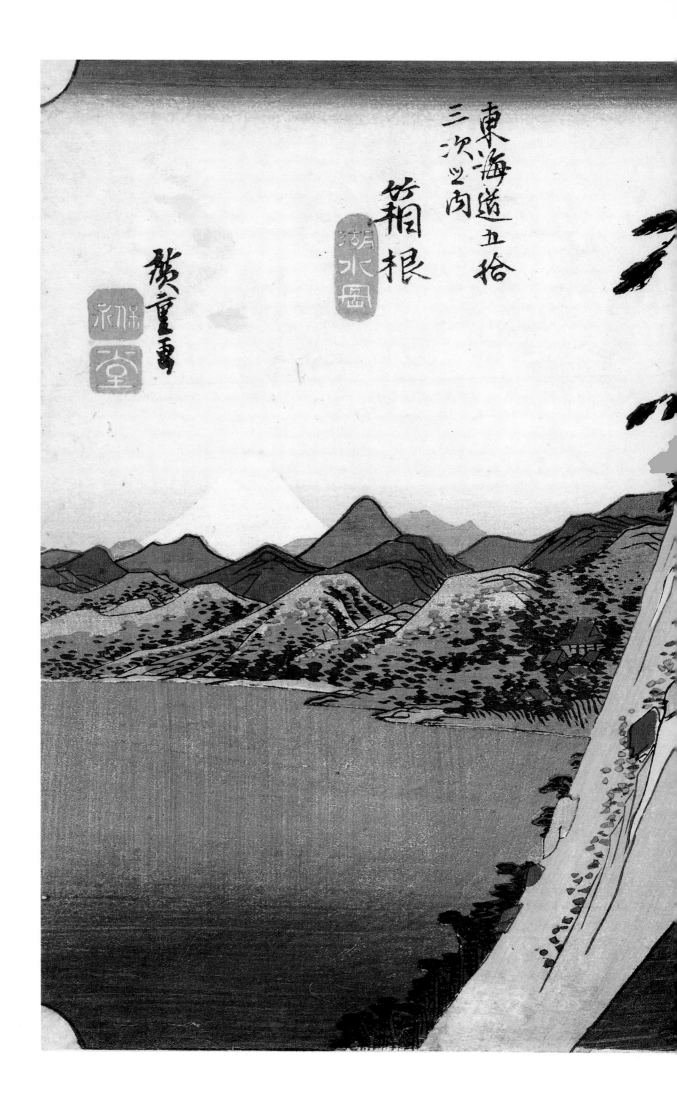

16

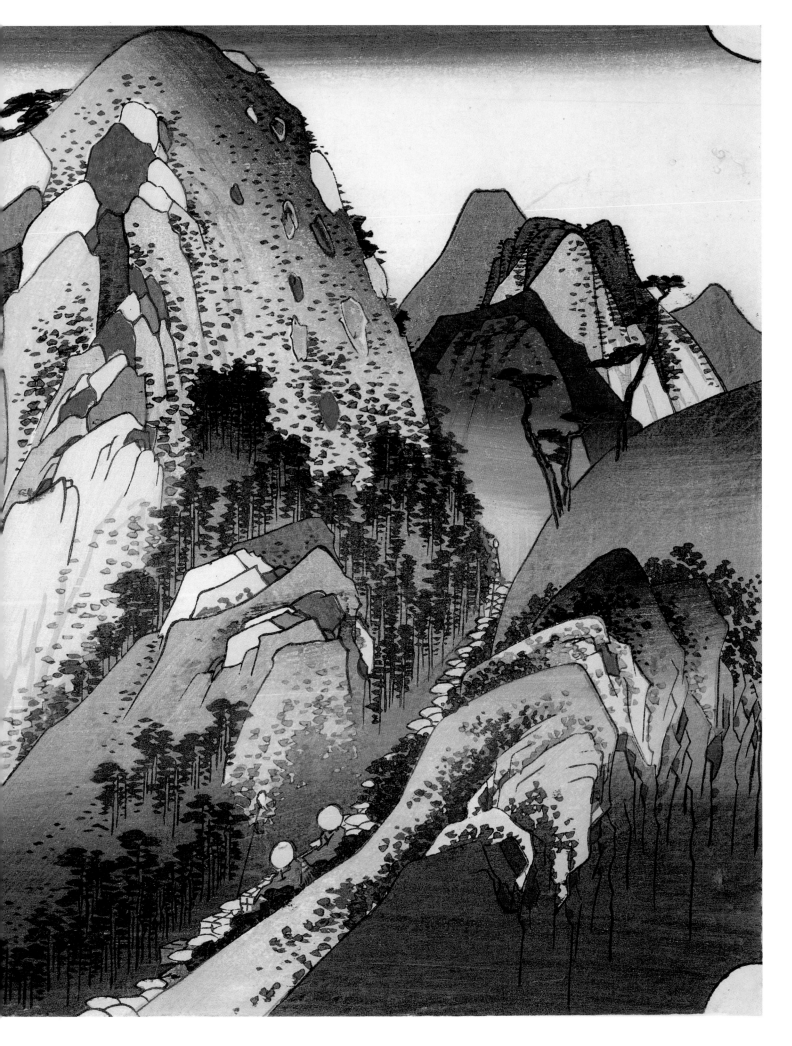

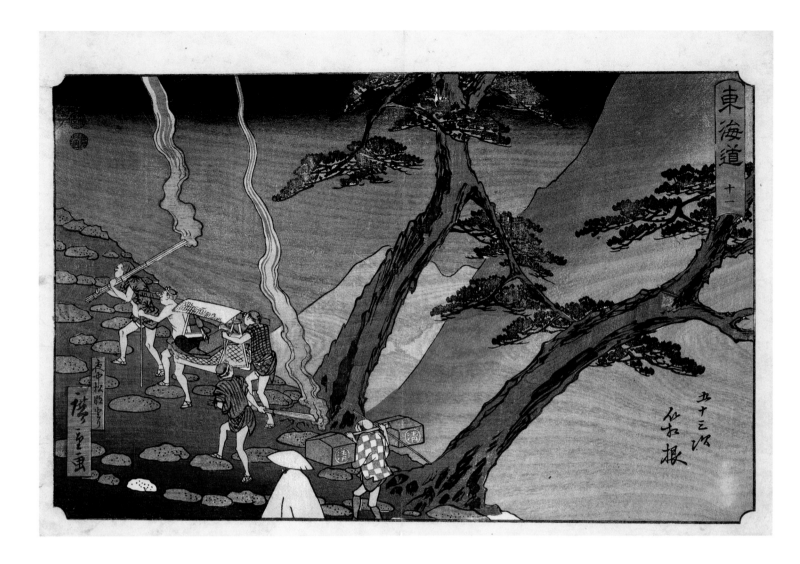

Nocturnal Journey with Torches near Hakone
The 11th station of the series "53 Stations of
the Tokaidō" (*Tōkaidō gojūsantsugi*), published
by Marusei (Maruya Seijirō), Reisho edition,
c. 1848
Colour print, ōban, 22 x 34.8 cm (8.6 x 13.7 in.),
border preserved

By torchlight, porters are carrying a traveller
over the Hakone Pass in a litter. In this bird's-eye
view, the mountain in the middle distance, the
rock-strewn path and the bizarre pines are all
cropped. This detail-like composition reinforces
the threatening nature of the scene. The colour
gradations (*bokashi*), too, in grey-green, brown
and grey-black, lend the scene an eerie atmo-
sphere.

PAGES 16–17:
The Lake near Hakone
The 11th station of the series "53 Stations of
the Tokaidō" (*Tōkaidō gojūsantsugi*), published
by Hōeidō (Takenouchi Magohachi), c. 1832
Colour print, ōban, 23 x 35 cm (9 x 13.8 in.),
edge cut

One popular pilgrimage led to the island of Enoshima, which was about
40 kilometres from Edo on a side road that led off from the Fujisawa postal sta-
tion. What attracted so many visitors to this island was not just its charming
situation, with its view of Mount Fuji, but also the colourful cult statue of the
Buddhist goddess Benzaiten, hidden in a grotto and only exposed to the view of
pilgrims every six years. As goddess of long life and eloquence, she was the pat-
roness of musicians and singers. In a triptych dating from about 1850, Hiroshige
reproduced the picturesque view of the rocky island and the groups of musicians
streaming towards the grotto (pp. 20–21). Individual troupes can be distin-
guished by their kimonos and the emblems on their parasols.

Likewise easily accessible from Edo was Mount Ōyama, the "great mountain",
whose waterfall was venerated as a sacred Shintō site and was visited by the
adherents of *shugendō*, a mixture of esoteric Buddhism and traditional nature
worship, who went there for the purpose of ascetic exercises (p. 19). The waterfall
was also known as the Rōben Falls, after the great founder of the Tōdaiji Temple
in Nara, the monk Rōben (689–773), who as long ago as 752 had allegedly ex-
posed himself to its cold, hard jet of water. Here the Buddhists venerated the god
Fudō Myōō, the "unshakable king of esoteric wisdom", who is symbolized on the
left of the picture by the sword around which a dragon is coiled. The task of the
grim, unshakable Fudō consisted in destroying human ignorance, hence the
sword with the dragon as one of his most important attributes. Hiroshige com-
posed this print, in the final year of his life, for the series "Mountain and Sea

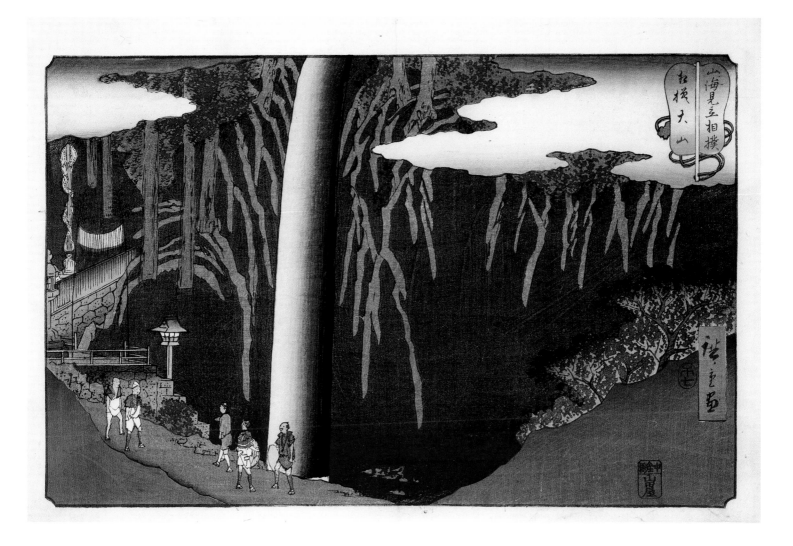

Compared to Wrestlers". In front of the waterfall, whose Prussian blue shading evokes connotations of a steel sword blade, a few pilgrims have gathered, evidently still hesitant about whether to venture the leap into the cold water.

In order to identify themselves, private travellers needed papers issued by the authorities in their home district or village; these gave their name and address and the purpose of their journey. Normally people travelled on foot and spent the nights at the post stations (*seki*) at inns that were at the disposal of the various social classes. Also available at the stations, however, were guides who were allowed to take travellers by litter or on horseback from one station to the next, and to bring another customer back. In one of the later series of the "53 Stations of the Tokaidō", dating from 1848 to 1852, Hiroshige depicted Hakone by night (p. 18). A group of porters and servants, accompanied by torch-bearers, are transporting a sleeping traveller in an open litter along a steep and stony mountain road. The composition, with steep jagged mountains depicted in silhouette, of which the viewer only has a partial view, and the road, lined by gnarled pine-trees, which seems to be leading nowhere, gives the nocturnal scene an eerie atmosphere. The viewer has a sense of the silence of the night and the tension of the porters.

Ōyama in Sagami Province

No. 12 in the series "Mountain and Sea Compared to Wrestlers" (*Sankai mitate zumō*), published by Yamadaya Shōjirō, 8th month 1858 Colour print, ōban, 21.9 x 34.4 cm (8.6 x 13.5 in.), border preserved

The waterfall on Mount Ōyama was a sacred Shinto site reserved for male pilgrims. To expose oneself to the cold water was an ascetic exercise believed to liberate body and soul from all evils. Buddhists also venerated Fudō Myōō here, the "unshakable king of esoteric knowledge". The mountain, indicated by a few lightly sketched grey ridges, and the blue shading of the waterfall, reminiscent of the blade of a sword, are, in their bold abstraction, typical of Hiroshige's late work.

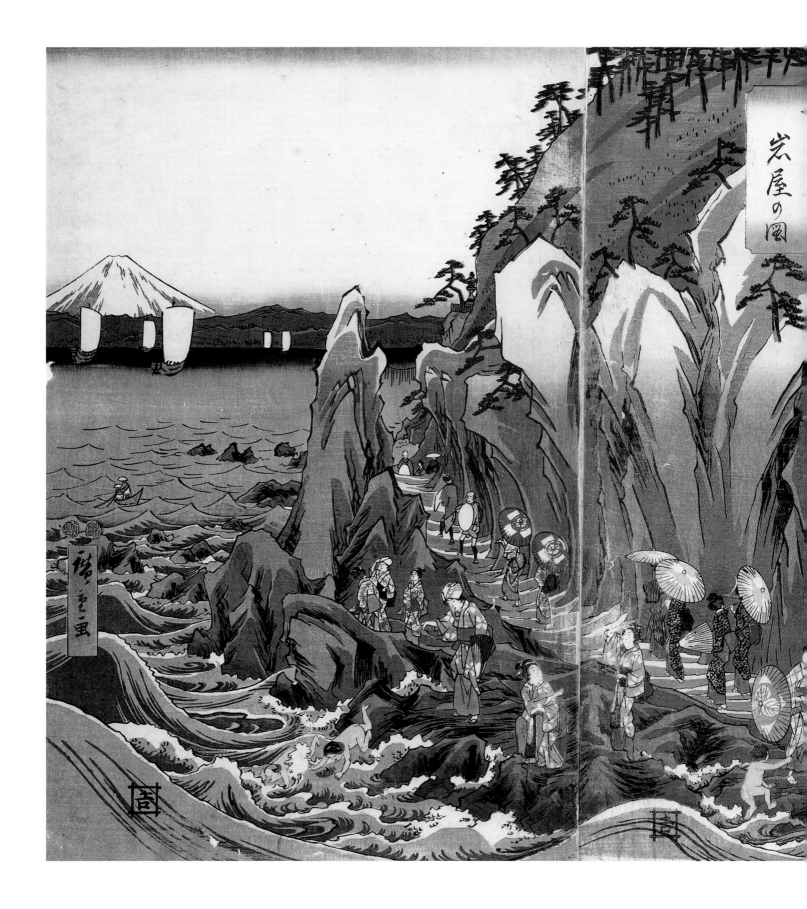

**Pilgrimage to the Shrine of the Goddess
Benzaiten in the Grotto near Enoshima
in the Province of Sagami**
Published by Sumiyoshiya Masagoro, c. 1850
Colour print, ōban, triptych, 36.6 x 74.2 cm
(14.4 x 29.2 in.)

Hiroshige gives us a bird's-eye view of the rocky
island, crowded with female pilgrims. Their

destination is the statue of the goddess Benzai-
ten in the grotto, which was open to view only
every six years. The breaking waves are capped
by white foam and are enlivened by internal
lines and areas in a darker blue. Their shape
takes up the silhouette of Mount Fuji, recogniz-
able on the horizon.

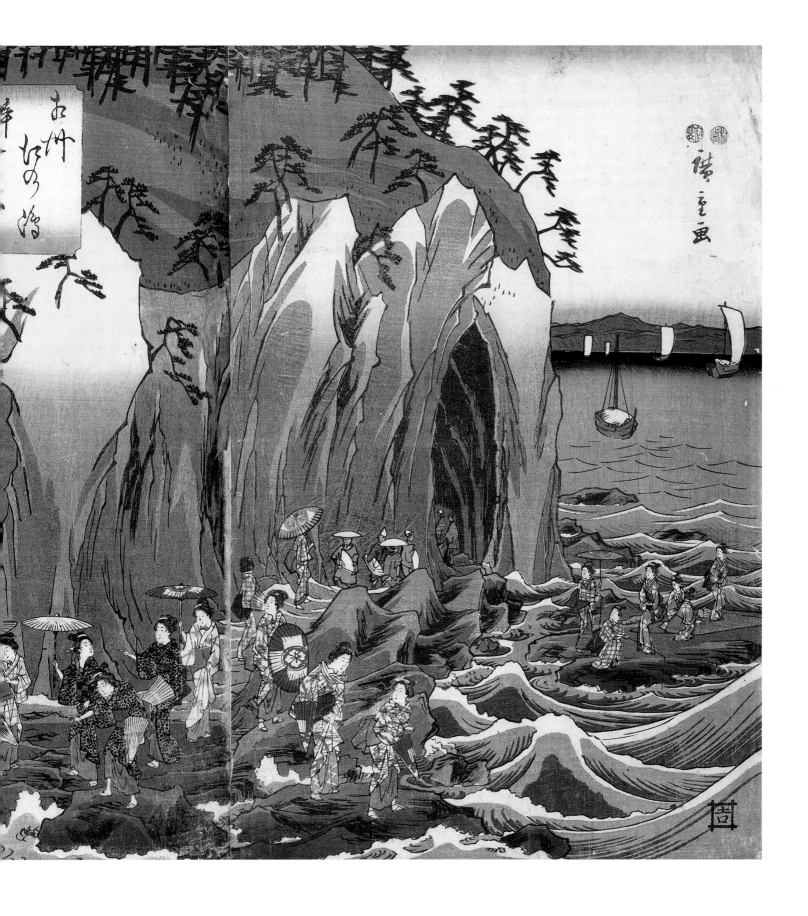

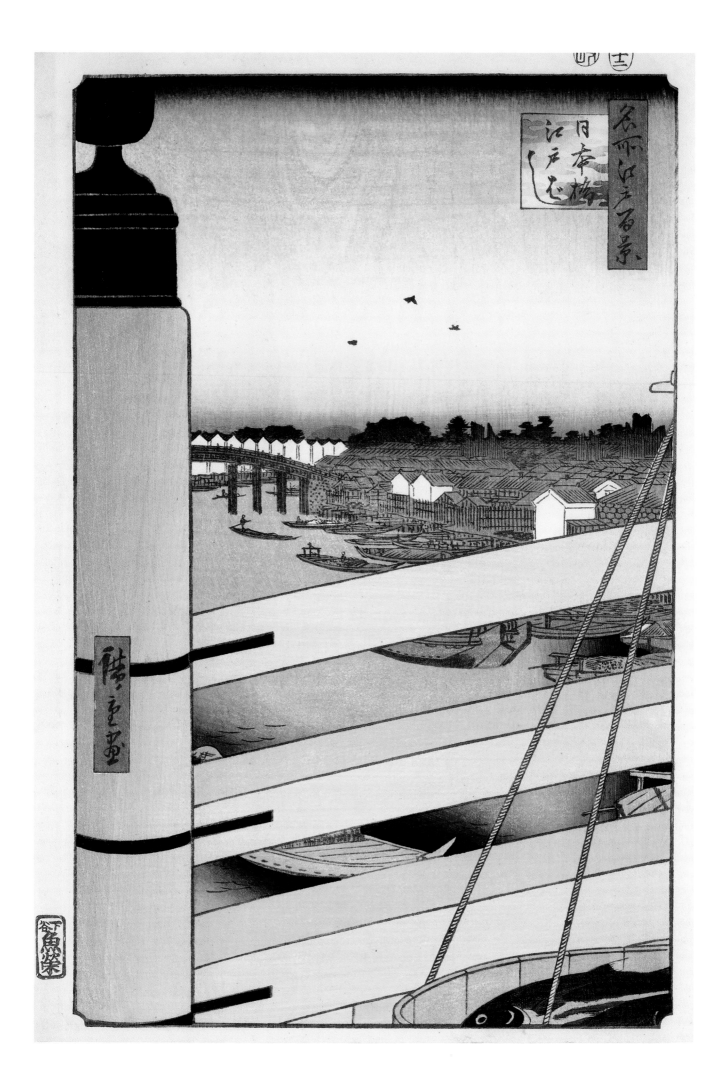

Urban Culture in Edo

In the early 19th century, with a population of around 1.5 million inhabitants, Edo developed into one of the most densely populated cities in the world at that time. The country's poor came to seek their fortune and look for opportunities for economic advancement. The city was arranged in concentric circles around the shogun's palace, which loomed over everything. It was surrounded by two external moats, which were fed with water from the Sumida and Kanda rivers. Thus arose a network of canals which served to bring water to the moats. Between the two moats were the residences of those *daimyō* who were close to the shogun, while further *daimyō* residences extended beyond the outer moat into the residential quarters of the city. The people lived in the so-called lower city (*Shitamachi*) around the Nihonbashi Bridge (*Nihonbashi*) and beyond the Sumida River.

Under Yoshimune, the eighth shogun (ruled 1716–1745), parks were laid out in the city, designed to serve the population as places of relaxation. In Asukayama and Gotenyama, for example, the banks of the Sumida were planted with cherry trees, as were the banks of the upper reaches of the Tama River. They invited people to come and stroll, and were the venues for numerous pleasurable activities, such as admiring the cherry blossom in spring, watching firework displays during the warm summer nights, and observing the moon in the autumn and winter.

In his series of "Famous Views of the Eastern Capital" (*Tōto meisho*), which had appeared as early as 1831, Hiroshige captured the tranquil, spring-like atmosphere of the evening cherry-blossom viewing in Gotenyama (p. 24). A low, tender-green hill in the foreground with cherry-trees in blossom, notice boards, and a few visitors leaves open a view over roofs and the sea. The sky is streaked with red clouds, and the sheet is framed by an edge of meander patterns in russet, both of which are stylistic elements Hiroshige had adopted from Western copperplate engravings. But in the Yoshiwara quarter too, the brothel district, which was transferred from Nihonbashi to the north of the city after the disastrous fire of 1657, there was ample opportunity to admire the splendour of the cherry blossom on the Gochōmachi, the main traffic artery, in the evening light (pp. 26–27). In this triptych, which dates from around 1835, Hiroshige has used the bird's-eye-view convention known from traditional painting in the Japanese style, with banks of cloud to indicate depth. However his clouds are not in gold leaf or gold

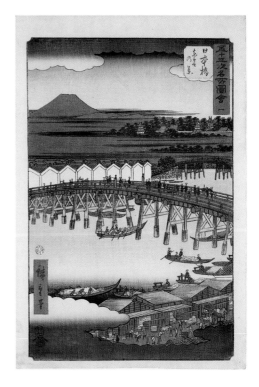

Nihonbashi Bridge at Dawn
The first station of the series "Famous Views of the 53 Stations" (*Gojūsantsugi meisho zue*) in vertical format, published by Tsutaya Kichizō, 1855
Colour print, ōban, 34.3 x 22.6 cm (13.5 x 8.9 in.), border preserved

Nihonbashi Bridge and Edobashi Bridge
From the series "100 Famous Views of Edo" (*Meisho Edo hyakkei*), published by Uoya Eikichi, 1857
Colour print, ōban, 33.9 x 22.1 cm (13.3 x 8.7 in.), border preserved

23

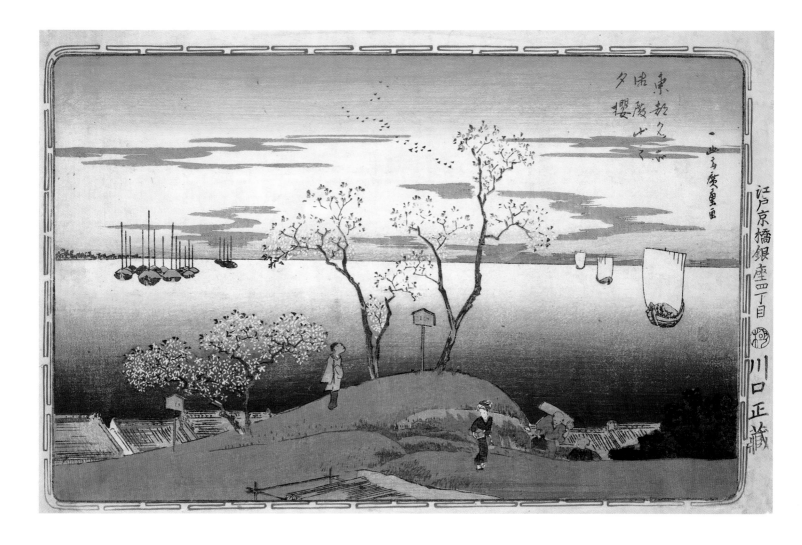

Evening Cherry Blossom near Gotenyama
From the series "Famous Views of the Eastern
Capital" (*Tōto meisho*), published by Kawaguchi
Shōzō, c. 1831
Colour print, ōban, 22.1 x 35.9 cm (8.7 x 14.1 in.),
border preserved

Viewing the cherry blossom is still a cult even in
modern Japan. Already in the 18th and 19th cen-
turies, city dwellers would treat themselves to
this luxury, spending their leisure hours in ad-
miration of the intoxicating beauty of the blos-
soms, for example in Gotenyama, where the
banks of the Sumida River were planted with
cherry trees.

PAGE 25 TOP:
Fireworks near Ryōgoku Bridge
From the series "Famous Views of Edo" (*Edo
meisho no uchi*), published by Senichi (Izumiya
Ichibei), c. 1832/33
Colour print, ōban, 22.5 x 36.2 cm (8.9 x 14.3 in.),
border preserved

PAGE 25 BOTTOM:
**Viewing the Cherry Blossom on Nakanochō
Street in the Yoshiwara Quarter**
From the series "Famous Views of Edo" (*Edo
meisho*), published by Yamadaya Shōjirō,
1840–1858
Colour print, ōban, c. 22 x 34.3 cm (8.7 x 13.5 in.),
border preserved

dust (a luxury which the censors probably would not have allowed), but in a del-
icate pink and bluish-green, which gives even more effect to the luminescence of
the blossoms. Hiroshige must have been amused by the fact that in the brothel
district the concentration of the men on the cherry blossom was sorely tried at
times, or maybe was directed rather toward the beauties sunk in reverie as they
themselves contemplated the blossoms. This at least is hinted at by his view of
the procession to the cherry-blossom viewing in the Yoshiwara quarter (p. 25
bottom) from the series "Famous Views of Edo" (*Edo meisho*), which appeared
between 1840 and 1858.

In the hottest months of the year, one way to cool down was to take a boat
trip on the Sumida River, where a favourite activity in the vicinity of the Ryōgo-
ku Bridge was to watch the fireworks that on the 28th day of the 5th month
ushered in the season of the *kawabiraki* (opening of the river). There one could
hire a pleasure boat (*yanebune*) decked out with red lanterns, on which geishas
or girl musicians provided entertainment and offered the guest food and drinks
(pp. 86–87). Hiroshige often depicted the fireworks over the Ryōgoku Bridge and
did so differently each time (p. 25 top). In this triptych, which dates from around
1850, the geishas in their colourful costumes, stepping into the red boat decked
out with lanterns, are posed in a lively movement as they turn towards each
other, and stand out clearly against the Ryōgoku Bridge, which is plunged in
darkness, and the pleasure boats beneath it. The outlines of a few weeping wil-
lows waft into the picture from above, hinting at a pleasant breeze. In between,
three fireworks can be discerned in the sky. The viewer may wonder what the
women at the nocturnal fireworks are talking about in such an animated fashion.

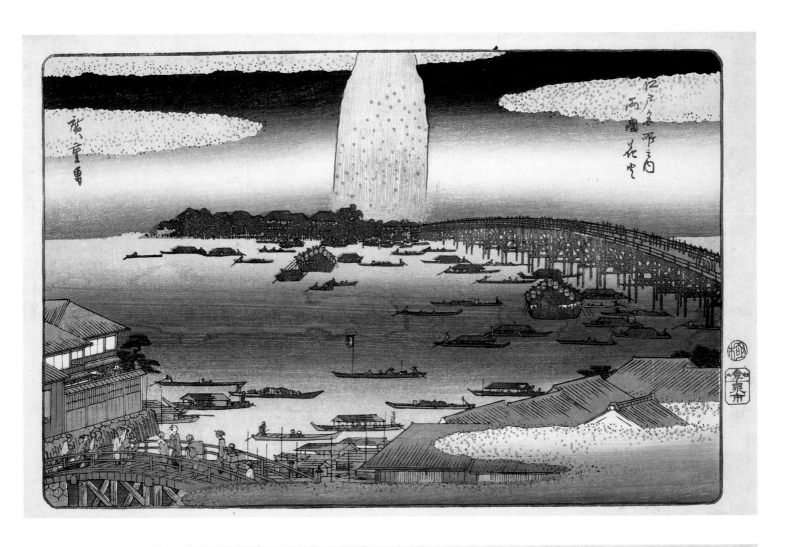

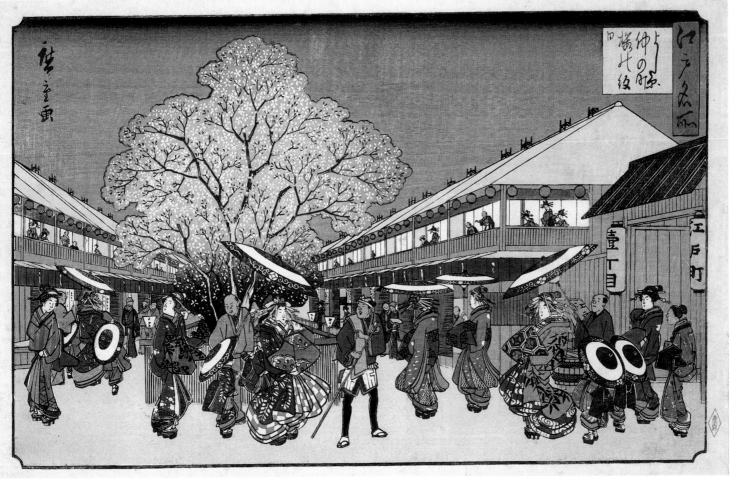

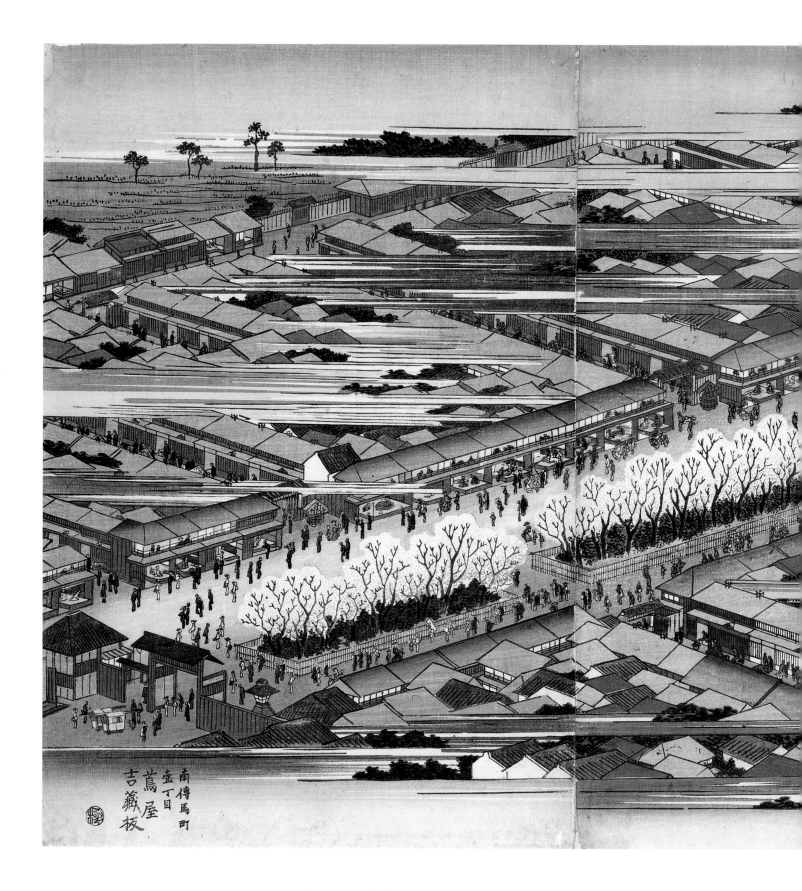

南傳馬町壹丁目蔦屋吉藏板

Cherry Trees in Full Blossom in the 3rd Month on Gochōmachi Street in the Yoshiwara Quarter
From the series "Famous Views of the Eastern Capital" (*Tōto meisho*), published by Tsutaya Kichizō, c. 1835
Colour print, ōban, triptych, 37.4 x 76.5 cm (14.7 x 30.1 in.)

Yoshiwara was the pleasure and brothel quarter of Edo, where everything to quicken a man's heart was to be had, albeit at an outrageous price, and only until the money ran out. Hiroshige has depicted the Yoshiwara quarter from a bird's-eye perspective and uses the banks of mist to convey spatial depth, as was done in traditional Japanese painting.

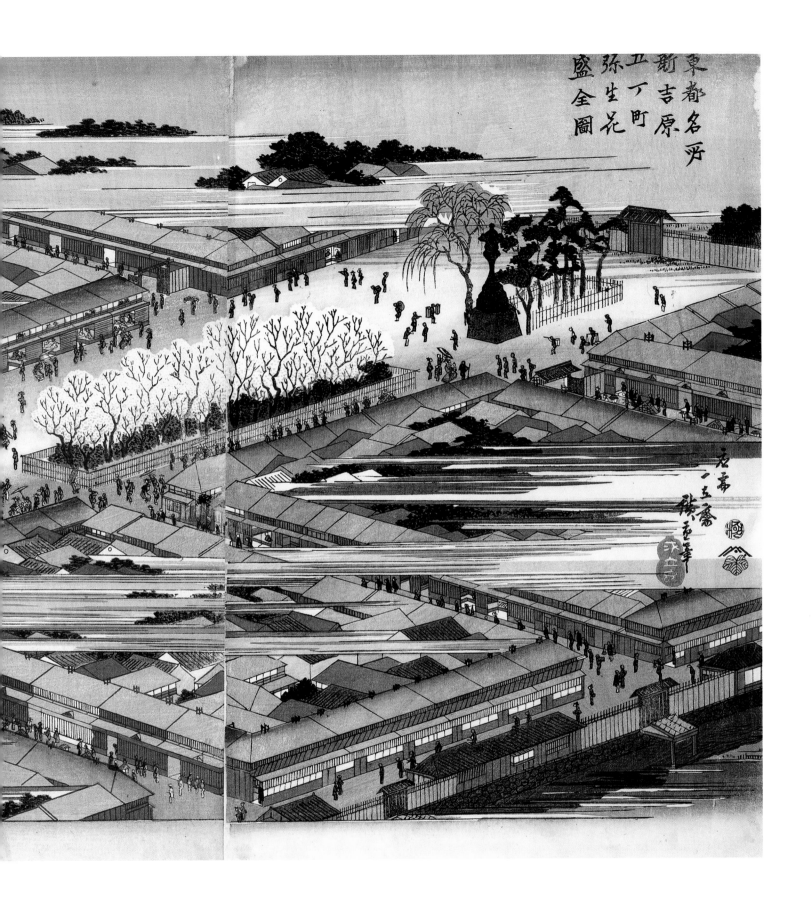

東都名所
新吉原
五丁町
弥生花
盛全図

名所一五番

廣重画筆

27

Maybe about the guest they are awaiting? The contrast-rich coloration is also suggestive, challenging the viewer to wonder about the source of the light that illuminates the women so brightly. Depictions like these, which leave much open, captivated the urban public, offering as they did occasion for a whole variety of speculation.

The military government propagated Confucianism and the Confucian social ethic, according to which society was divided into four estates, membership of which was hereditary. At the top of the social hierarchy was the nobility of the sword (samurai), followed by farmers, craftsmen, and finally merchants. Altogether beneath the hierarchy of estates were beggars and prostitutes, actors and wandering artistes, butchers and leather workers. With their extremely strict code of honour, the samurai, during the long age of peace which offered them little chance to put their military virtues to the test, increasingly turned to the life of the civil servant. They had no land of their own, and were dependent on the wages paid to them by their feudal lord or the shogun as the case might be. Inflation, a constantly growing population, and the increasing affluence of the merchants and craftsmen, led to their impoverishment.

While the farmers were the only estate that paid taxes to the shogun or the *daimyō*, in other words bore the main burden of the state's finances, the craftsmen as a rule made a passable living. They formed part of the urban class, known as *chōnin*, who enjoyed a considerable education and were among the buyers of the cheap ukiyo-e woodblock prints, which could be acquired for 16 *mon*, the price of a bowl of noodle soup. As for the merchant, his profession was regarded by Confucianism as so dishonourable that it would be equally dishonourable for anyone to accept tax on the income derived from it. After all, he made his money not by his own efforts, but only by exploiting the fruits of the labour of others. So while merchants had no political power, many of them accumulated substantial fortunes, and led extravagant lifestyles. Between 1832 and 1838, the rural population and the urban poor in particular were the victims of a famine caused by a harvest failure, and the disproportionate gap between rich and poor was made all the more obvious as a result. The consequence was unrest and riots, which the military government sought to put down by tightening its control over all areas of life.

Through their consumption, the *chōnin* represented the actual economic driving force of the country, and alongside the official culture of the feudal aristocracy, which was geared to China and Confucianism, they developed a flourishing urban culture. An impression of the colourful variety of these city people is conveyed by Hiroshige's view of Nichōmachi Street (p. 33) in around 1835, in the series "Famous Views of the Eastern Capital" (*Tōto meisho*). The beholder is looking upon a mass of people making their way along the street where the Kabuki theatres were located. Alongside affluent kimono-clad gentlemen, we see porters, waiters with large trays of food, and also a few girl musicians and courtesans. Alongside the fashionably dressed ladies of the brothel districts, great interest was taken in the Kabuki theatre (pp. 30–31), the sumo tournaments and also traditional pursuits. Literary and musical entertainment was a source of enjoyment, poetry groups were formed and met for contests, and they could even afford to have their verses printed in illustrated private editions. People took lessons in Noh plays, took an interest in the breeding of imported exotic plants, and visited aviaries in which all sorts of birds could be admired.

Excursions were made to famous gardens and viewpoints, depending on the season, while a taste for gourmet cuisine and choice regional specialities was

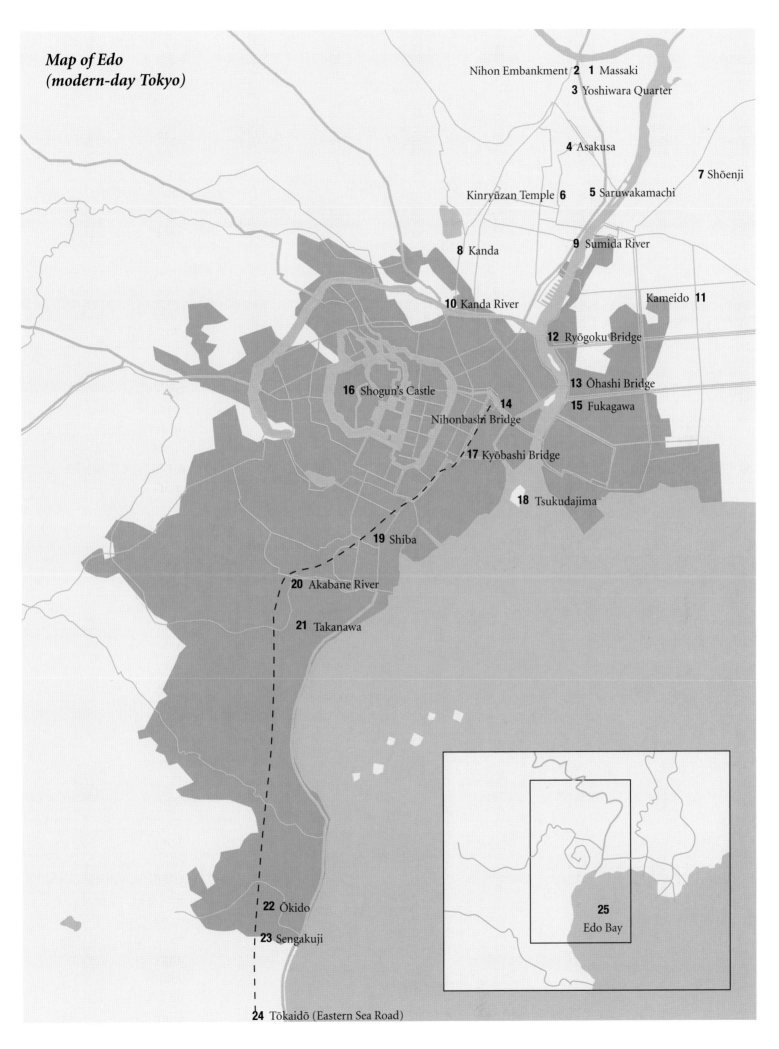

Map of Edo
(modern-day Tokyo)

Nihon Embankment **2** **1** Massaki

3 Yoshiwara Quarter

4 Asakusa

7 Shōenji

Kinryūzan Temple **6** **5** Saruwakamachi

8 Kanda **9** Sumida River

Kameido **11**

10 Kanda River

12 Ryōgoku Bridge

13 Ōhashi Bridge

16 Shogun's Castle **15** Fukagawa

14

Nihonbashi Bridge

17 Kyōbashi Bridge

18 Tsukudajima

19 Shiba

20 Akabane River

21 Takanawa

25
Edo Bay

22 Ōkido

23 Sengakuji

24 Tōkaidō (Eastern Sea Road)

***A Kabuki Performance in the Saruwakachō
Theatre***
From the series "Famous Views of the Eastern
Capital" (*Tōto meisho*), published by Sanoki
(Sanoya Kihei), c. 1849/50
Colour print, ōban, 24.4 x 35.6 cm (9.6 x 14 in.),
border preserved

Hiroshige's depiction of a Kabuki performance
in the Saruwakachō Theatre is in the tradition
of the *ukie*, the so-called "perspective pictures".
Already in the first half of 18th century some
woodcut artists had begun to use Western cent-
ral perspective to depict the interiors of theatres
and tea-houses. After a fire in 1841 the new Saru-
wakamachi theatre quarter was erected near
Asakusa. The name commemorates Saruwaka
Kanzaburō, the founder of the Edo-period Ka-
buki theatre.

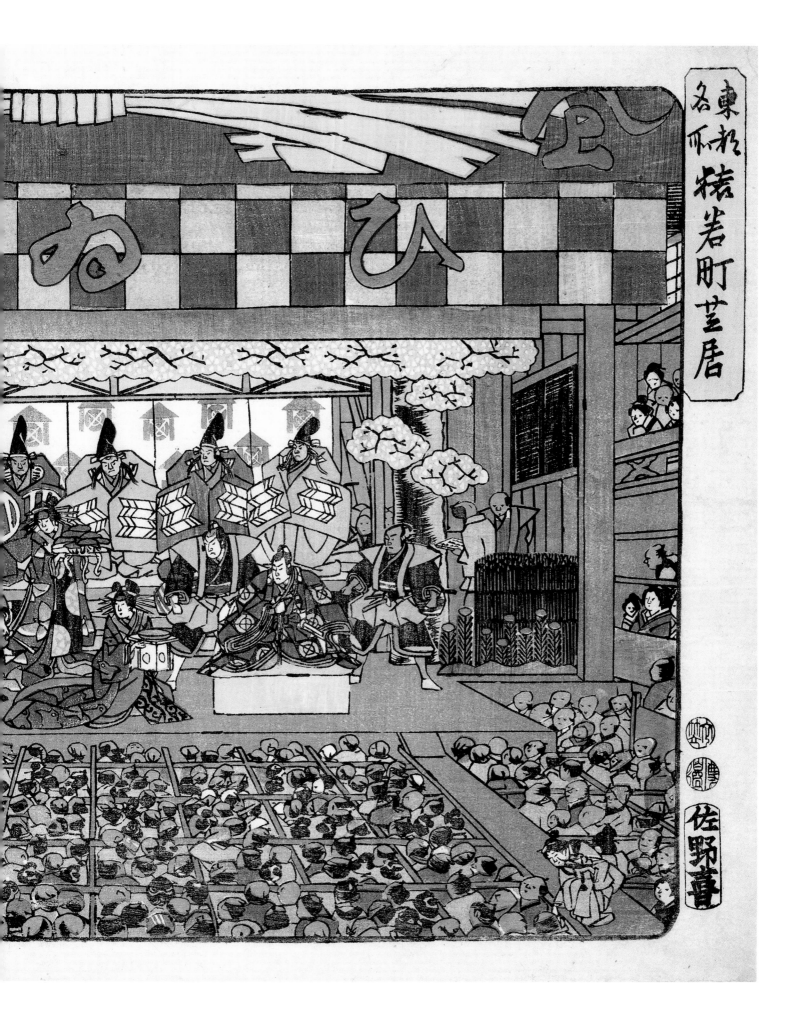

developed, and everyone knew which were the best restaurants and tea-houses. Between 1835 and 1842 Hiroshige devoted a 26-part series to the top restaurants and tea-houses in Edo (*Edo kōmei kaitei zukushi*). The Nikenjaya tea-house was located next to the Hachiman shrine in Fukagawa (p. 89) and occupied two buildings around an inner garden with palms. In the background one can recognize the red *torii* flanked by two stone lanterns, which marked the entrance to the shrine. With raised umbrellas, two courtesans are taking shelter beneath the palms from a sudden shower, indicated by needle-thin lines. On the right, two gentlemen in animated conversation are leaving the entrance of the elegant and restrained establishment. The palette, dominated by bluish-green and ochre-brown tones, convincingly reflects the dull weather.

People read a lot and were always well informed about the latest developments. Alongside demanding collections of poetry, and novels in which classical material was reworked, illustrated travel literature had enjoyed increasing popularity since the 18th century. In 1802 a brilliant humorous book by Jippensha Ikku (1765–1831), whose title (*Tōkaidō chū hizakurige*) can be loosely translated as "On Shanks' Pony", caused a furore. It described the comic adventures of two typical, fairly vulgar petty bourgeois from Edo who were journeying together along the Eastern Sea Road. Landscape woodcuts were bought either as souvenirs of one's own journey and its impressions, or in wistful anticipation of the famous sights and sites that one dreamt of seeing oneself one day, or else simply because their succinct, humorous depictions were enjoyable in themselves and provided welcome material for conversation.

View of the Hoteiya Textile Store
From the series "Famous Views of the Eastern Capital" (*Tōto meisho*), published by Ningyōya Takichi, c. 1857
Colour print, ōban, 26 x 36.5 cm (10.2 x 14.4 in.), border preserved

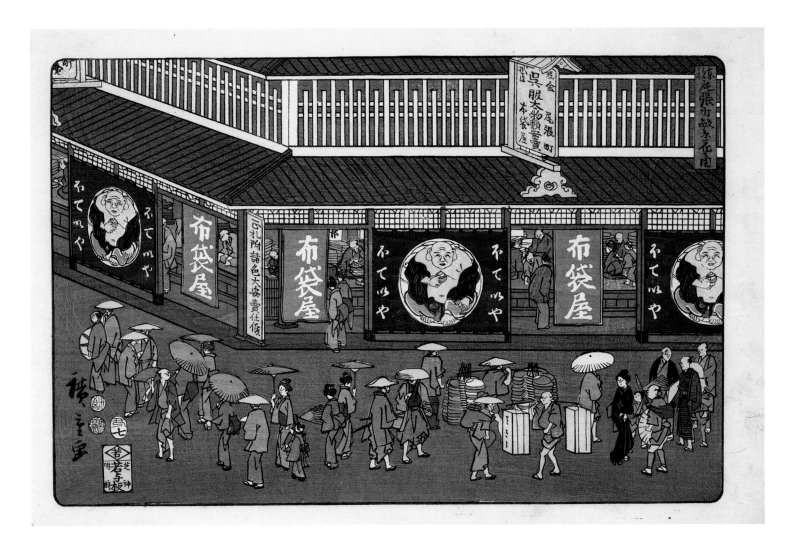

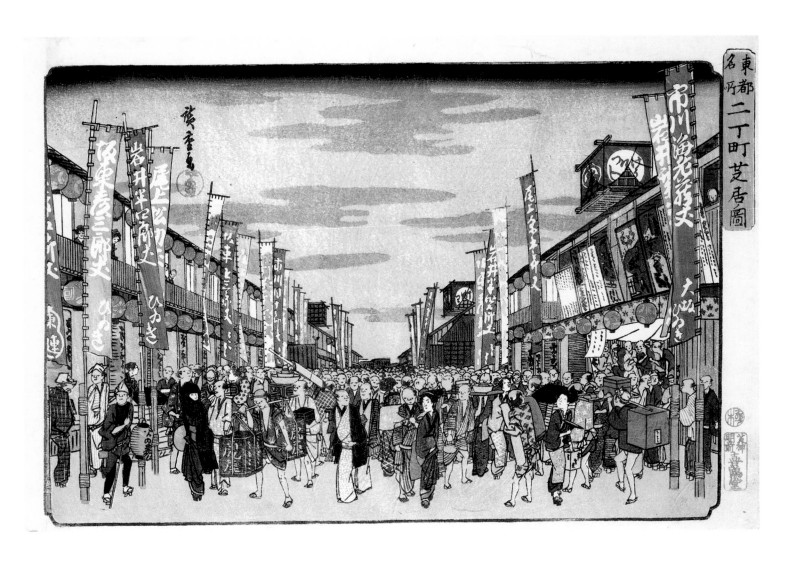

Kabuki Theatre in Nichōmachi Street
From the series "Famous Views of the
Eastern Capital" (*Tōto meisho*),
published by Sanoya Kihei, c. 1835
Colour print, ōban, 22.5 x 34.3 cm (8.9 x 13.5 in.),
border preserved

People are making their way through
the street to the Kabuki theatre.
Alongside affluent kimono-clad gentlemen
are porters, restaurant employees with trays
of food, and individual girl musicians and
courtesans. The Kabuki theatre was one
of the indispensable pleasures of bourgeois
citizens (*chōnin*).

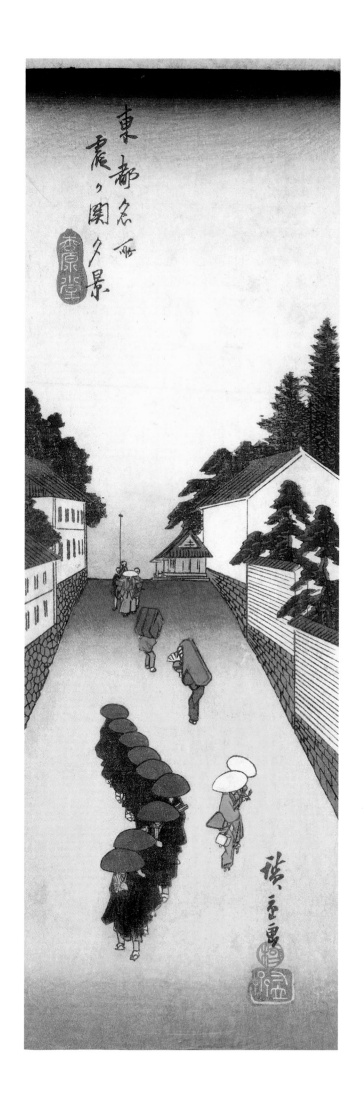

The Influence of Western Graphic Techniques on the Japanese Landscape Print

Trade contacts with the Dutch also led to the study of the Dutch language and Dutch books, initially via the interpreters and translators in Nagasaki. The head of the Dutch trading-post on the island of Dejima was required once a year (after 1790 it was once every five years), in the company of the trading-post doctor, to go to Edo in order to appear at an audience with the Shogun, bringing tribute gifts. This gave scholars in Edo the opportunity to make contact with the Dutch.

In 1720 Tokugawa Yoshimune decreed a relaxation of the import ban on European books that had already been translated into Chinese, and in 1740 he despatched scholars to the island of Dejima with instructions to translate scientific Dutch books into Japanese. Although direct contact with the Dutch was restricted, something called *rangaku*, "Dutch science", emerged in scholarly circles, which acted as the conduit for European knowledge to reach Japan. In view of the increasing threat posed by Russia, the government at the end of the 18th century endeavoured in systematic fashion to gather knowledge of world geography and Western science and weapons technology, and in 1811 even established a "Translation Office for Dutch-language Books".

Pictures employing perspective were called "flowing" or "floating" pictures (*uki-e*), alluding to the phenomenon whereby the gaze of the viewer was drawn into the depth of the composition or conversely the picture seemed to float out to the viewer. Several copies of Gerard de Lairesse's 1707 book, *Het Groot Schilderboek* (the title of the English translation is *A Treatise on the Art of Painting*), in which the vanishing points and lines of linear perspective are explained in detail, found their way to Japan, and as early as the 1740s the first woodblock prints with interior perspective views of Kabuki theatres appeared. Hiroshige too left a classical, central-perspective view of the interior of the Saruwakachō Kabuki theatre in the series, dating from around 1849/50, of "Famous Views of the Eastern Capital" (pp. 30–31).

A fashion developed for peep or raree shows. When the viewer looked through an opening with a lens, his whole surroundings disappeared, creating the sensation of literally "being in the picture". Imported examples were set up at fairgrounds or pleasure parks, to the great enjoyment of the urban population. The available pictures included not only imported copperplate landscape engravings, but also imitations made in Japan and indeed Japanese originals with

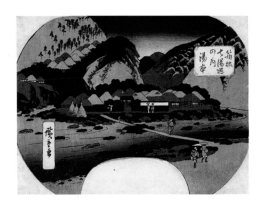

The Yumato Spring
From the series "Round Trip to the Seven Hot Springs near Hakone" (*Hakone shichi yu meguri no uchi*), no publisher's mark, 1830s
Colour print, fan, 20.3 x 27.9 cm (8 x 11 in.)

Hiroshige composed numerous fan-shaped prints, originally intended to be stuck to the front and rear sides of a rigid bamboo framework and used as fans. Prussian blue had been imported into Japan since the late 1820s and he valued it for its simultaneous luminosity and transparency.

Evening View of Kasumigaseki
From the series "Famous Views of the Eastern Capital" (*Tōto meisho*), published by Fujiokaya Hikotarō, c. 1835
Colour print, chūtanzaku, 37.8 x 12.5 cm (14.9 x 4.9 in.), edge cut

The narrow vertical format known as "chūtanzaku" was hardly appropriate for experiments with central perspective. The lines of the natural stone foundations and corresponding façades in Kasumigaseki which should lead to a vanishing point do not obey any logic. The impression of spatial depth is created only by relative size: the monks in the foreground are much larger than the *daimyō's* escort in the distance.

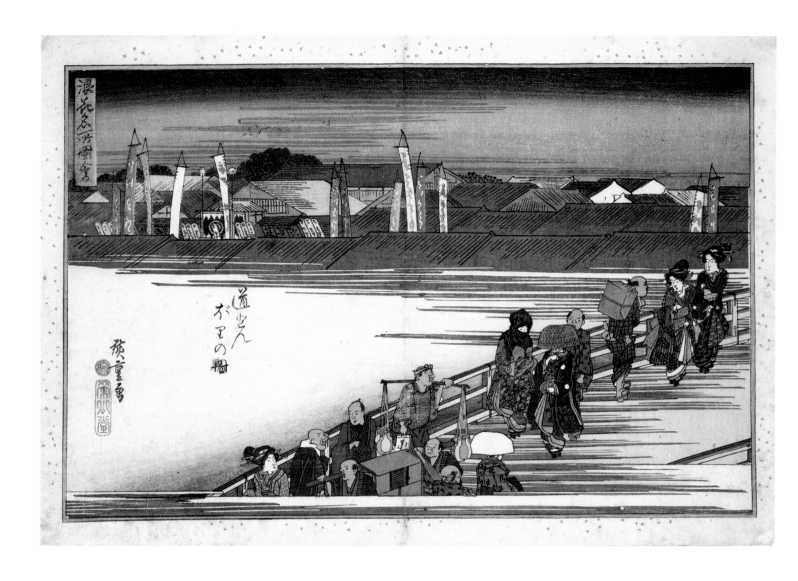

View of the Dōton Canal
From the series "Famous Views of Ōsaka"
(*Ōsaka meisho*), published by Eisendō (Kawa-
guchi Shōzō), c. 1834
Colour print, ōban, 22.5 x 35.2 cm (8.8 x 13.9 in.),
border preserved

Hiroshige depicts the bridge over the Dōton
Canal as a diagonal across the picture. The
pleasure quarter of Osaka is merely hinted at by
the advertising banner that can be seen between
the grey roofs of the houses and the grey-blue
evening sky. To create an impression of depth,
Hiroshige uses grey hatching, a technique he
adopted from European copperplate engraving.
With a keen sense of observation, he has cap-
tured the plain speaking between the people
on the bridge: male passers-by are openly ac-
costing courtesans, while summing up modestly
shrouded women with importunate looks;
litter-bearers are shouting for others to make
room, to the unconcealed annoyance of a bald
old man.

imposing figural scenes and cityscapes. Towards the end of the 18th century, peep
shows were updated to include lighting effects. Pictures could now be backlit or
partially dimmed through the use of hidden flaps, so that daylight scenes could
be transformed into nocturnal views.

Also of almost inestimable importance for the art of woodblock prints were
the translations that appeared in the latter half of the 18th century of anatomical
and surgical textbooks and botanical and zoological encyclopaedias, as well as
writings on cartography and surveying techniques. They confronted the Japanese
with a totally new, analytical view not only of the body and its anatomy, but also
of the world and nature and how it was made. It is difficult for us to imagine the
shock that this alien view of the world must have unleashed among those who
concerned themselves intensively and intelligently with their environment. Not
only the readers of these books, but also the artists who were commissioned to
produce woodcut reproductions of the copperplate engravings with which they
were illustrated, could not help familiarizing themselves with the rules of West-
ern linear perspective and the depth produced by central perspective, or of the
methods employed for the plastic representation of three-dimensional bodies.
We can assume with certainty that Hiroshige was familiar with European en-
gravings, for he experimented now and again with shading. This is shown for
example by the impressive nocturnal view of the theatre and pleasure quarter of
Dōtonbori (p. 36) from the series "Famous Views of Ōsaka", which was published
by Kawaguchi Shōzō of the Eisendō publishing house around 1834.

The idealistic perception of nature which had endured for more than a thousand years was suddenly confronted with a verist world view, and it goes without saying that it was not so much the conservative painting schools, but, alongside the scholars and intellectuals, above all the enterprising woodblock-print artists who received and studied this phenomenon with great open-mindedness. In Hiroshige's œuvre there are, in the first half of the early 1830s, perspective depictions which come across as amateur and clumsy, and for this reason alone exercise a particular fascination. For example the *Evening View of Kasumigaseki* (p. 34), in which the vanishing lines of the natural-stone base of a *daimyō* residence and the zigzag of the projecting house fronts obey no sort of logic. The sense of distance is conveyed only by the fact that the *daimyō* escort with the standard-bearers is depicted much smaller than the group of dark-clad monks and the two musicians in profile. But only a short time later, perspective was evidently no longer any real problem for Hiroshige. The same station (p. 37) from the between 1835 and 1840 appeared series of "Famous Views of the Eastern Capital" (*Tōto meisho*) is now depicted with the correct perspective. Admittedly, central perspective was not a technique he wholeheartedly embraced or obstinately clung to. He liked traditional Chinese bird's-eye perspective (pp. 82–83, 92), or two-dimensional depiction in the Japanese style of painting (pp. 3, 26–27, 80) just as much, if not more, than Western perspective or else he combined all three compositional techniques when documenting his view of the world, his creativity effectively fusing disparate elements.

Kasumigaseki
From the series "Famous Views of the Eastern Capital" (*Tōto meisho*), published by Kikakudō (Sanoya Kihei), 1835–1840
Colour print, ōban, 22 x 34.9 cm (8.7 x 13.7 in.), border preserved

A few years later Hiroshige depicted the same street in Kasumigaseki (p. 34). He had by now mastered the technique of central perspective.

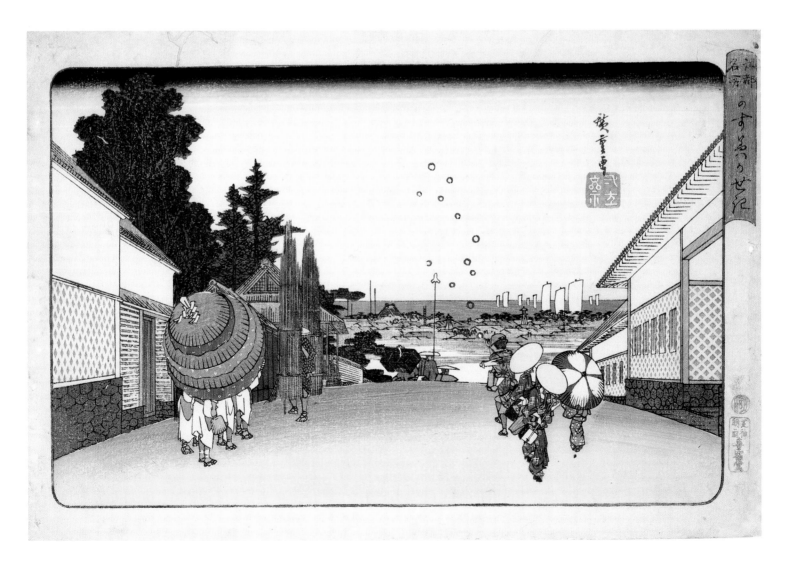

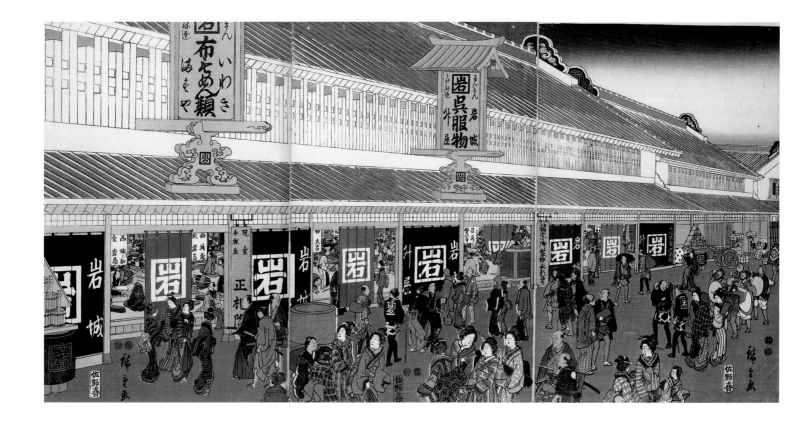

His series of depictions of fish must certainly have been influenced by Western visual habits, perhaps derived from zoological encyclopaedias. Even though there was a tradition in the painting of the Edo period of depicting swimming fish, Hiroshige's realism and the precise observation from nature are the expression of a new, verist view. His five river trout from a private edition dating from the early 1830s (p. 39 bottom) are notable for the accurate observation of their heads and the way their bodies are shaded to produce a three-dimensional effect. Their skeletons adapt to their flowing movement. At the upper left of the sheet is a poem by Haruzono Shizue: "The falling of the autumn rain does not disturb the beauty of the trout in the Tamagawa river, no dirt has sullied their shining skin." In the case of dead fish, for example the scorpion fish and the *isaki* fish on ginger roots from about the same time (p. 39 top), which are literally presented as "nature morte", the Western influence is beyond doubt, for the aesthetic depiction of dead creatures in the form of a still-life had no tradition in Japanese painting, and appeared in woodcuts only towards the end of the 18th century.

Street Scene outside Iwaki Masuya's Cloth-dealer's Shop
Published by Sanoya Kihei, c. 1850
Colour print, ōban, triptych, 36.4 x 78.4 cm (14.3 x 30.9 in.)

PAGE 39 TOP:
Scorpion Fish and Isaki Fish with Root Ginger
From a series depicting fish, published by Eijudō (Nishimura Yohachi), 1830–1835
Colour print, ōban, 25.1 x 36.4 cm (9.9 x 14.3 in.), edge cut

Evidently inspired by zoological encyclopaedias translated into Japanese, in the 1830s Hiroshige executed a series of still-lifes with fishes. The aesthetic depiction of dead animals in the form of still-lifes had no tradition in Japan and was quite certainly due to Western influences.

PAGE 39 BOTTOM:
Five River Trout
From a series depicting fish, no publisher's mark, c. 1835
Colour print, ōban, 25.2 x 36.5 cm (9.9 x 14.4 in.), edge cut

Hiroshige's depiction of river trout is based on precise observation of nature and differs markedly from the idealized depiction of "lucky" fish in the tradition of the classical schools of painting.

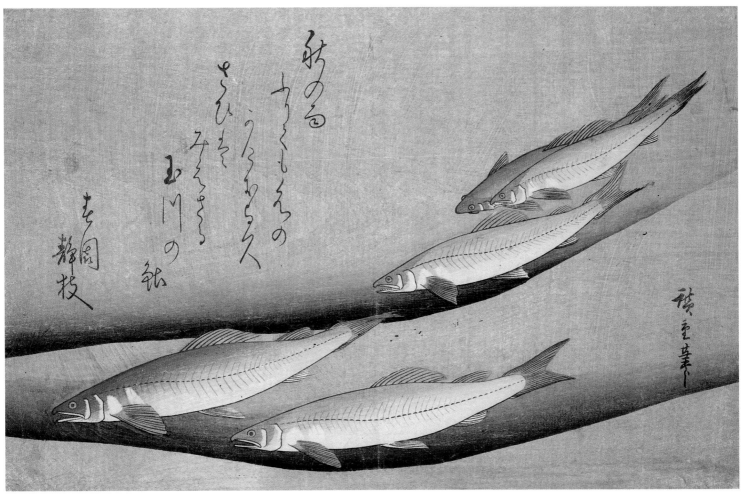

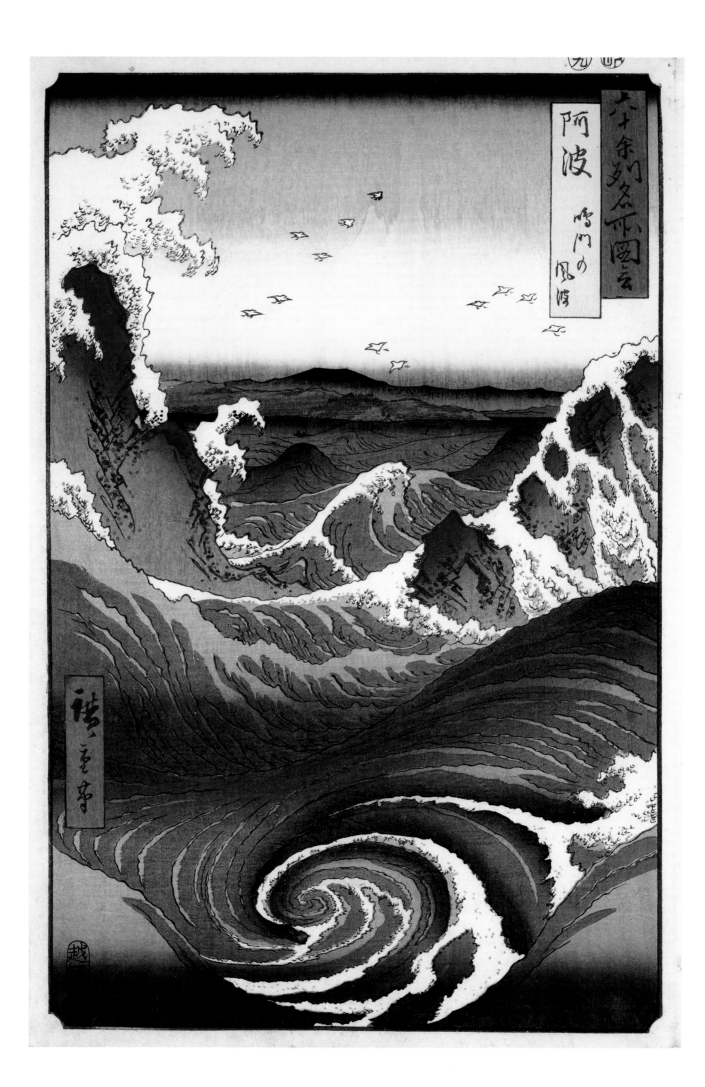

The Technique of the Ukiyo-e Woodblock Print

The ukiyo-e woodblock print had its origins in the tradition of the urban studio painters (*machi eshi*) who as anonymous professional artists did not belong to the recognized schools of painting and carried out cheap commission work. In order to meet the steadily growing demand for pictures, they developed and perfected the woodblock print as a means of mass-production, which ultimately became a highly varied and differentiated publishing business that met the needs of the middle classes perfectly.

At first the woodcuts were printed in black only; subsequent hand-colouring could be carried out if required, but by 1765 polychrome prints had reached full maturity. This was the result of a division of labour whereby the artist was first commissioned by the publisher to design a particular motif or series. The woodblocks were carved not by the artist himself, but by specialist craftsmen (*horishi*), while the prints in turn were made individually by printers (*surishi*). The planning, management and sales were in the hands of the publisher, who employed the printers, carvers and draughtsmen for low remuneration. The woodcut artists were, from the point of view of social status, craftsmen, not "artists" in the Western sense.

From 1790/91 the woodcuts bore a stamp from the censors saying *kiwame*, in other words approved, and from 1849 to 1857 also a date stamp and the mark of the current censors. In the so-called Reform Period (1841–1843) following the famine (1832–1838), portraits of beauties and actors were banned, along with luxury editions with more than seven or eight colour prints. What was called for were prints depicting historical heroes, designed to encourage virtues such as courage, loyalty and Confucian filial piety. In this way, the Tokugawa government sought to stem the tide of luxury, immorality and opposition that seemed to challenge their position.

Having been given a black-and-white drawing on thin translucent paper to work from, which was stuck on the front to the wood block, the woodcarver first cut an outline block on which the lines were precisely traced, and the surface of the areas between them was removed until the outline of the drawing, the part to be inked, stood proud of the rest. The artist was given proofs made from this outline block, and then for each colour block created a dedicated original on which he would write which areas of the picture were to be printed in that colour. The famous sheet with the rain in Karasaki (p. 43) from the series

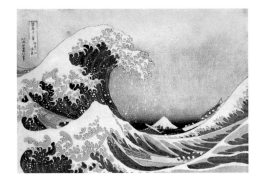

Katsushika Hokusai
Great Wave off Kanagawa
From the series "36 Views of Mount Fuji" (*Fugaku sanjūrokkei*), published by Nishimuraya Yohachi, 1831–1834
Colour print, ōban, 26.5 x 38.1 cm (10.4 x 15 in.)

Three boats seem to be in the process of being swallowed up by the gigantic wave; overpowered by the forces of nature the seamen gaze petrified into the abyss. Snowflakes dance in the air, the sky is grey, while in the distance rises the snow-capped cone of Mount Fuji. Hokusai's palette is restricted to Prussian blue, grey, and a light brown. The white areas have simply been left uninked during the printing process.

Awa Whirlpool
From the series "Famous Views of 60-Odd Provinces" (*Rokujū yoshū meisho zue*), published by Koshimuraya Heisuke, 10th month of 1855
Colour print, ōban, 34.5 x 23 cm (13.6 x 9.1 in.), border preserved

This print is a good example of an impression from a first print-run. Particular attention should be given to the fine colour gradations (*bokashi*) and shadings inside the blue areas.

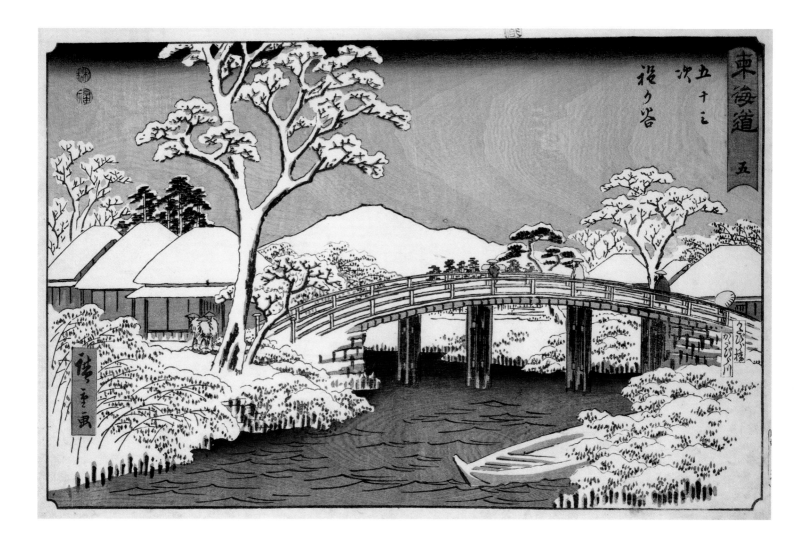

The Katabira River with Bridge near Hodogaya Station
The 5th Station from the series "53 Stations of the Tokaidō" (*Tōkaidō gojūsantsugi*), published by Marusei (Maruya Seijirō), Reisho edition, 1848–1850
Colour print, ōban, 22 x 34.8 cm (8.7 x 13.7 in.), border preserved

In Japan printing presses were not used, manual printing being preferred. The moistened paper was pressed against the printing block using circular movements of a pad called a *baren*; in the process, the grain of the wood was transferred to the paper. This effect was altogether desirable, because it could make an important contribution to the refinement of larger areas of colour, for example water or sky.

"Eight Views of Ōmi Province" (*Ōmi hakkei no uchi*) makes clear the challenges facing the woodcarver and printer, for example when reproducing the curtain of rain, in which every line has a tension of its own. The sweeping branches of the huge thousand-year-old pine looming silhouette-like from the haze are supported by bamboo rods. In front of the stony bank, there are two boats on the water. To the right of the tree a *torii*, stone lanterns, and the roofs of the Shintō shrine can be discerned, and in the background the masts of boats. The *kyōka* poem to the left of the title in red reads: "Though the soughing of the evening wind through the pines of Karasaki is famed far and wide, in the evening rain their rustling falls silent." Such poems (and their distinctive calligraphy) had long been an integral element of Japanese prints.

Often up to 12 colour blocks were used for a print. The printer was also responsible for mixing the pigments, which were for the most part derived from vegetable extracts. Towards the end of the 1820s, the powerful Prussian blue arrived in Japan, where it was known as *beroai* (i.e. Berlin blue); Hiroshige liked it because it was both brilliant and transparent, and often used it for the shading (*bokashi*) of the sky. A monochrome (*aizuri*) fan print (*uchiwae*) from the series "Round Trip to the Seven Hot Springs near Hakone" dating from the 1830s graphically demonstrates the undreamt-of nuances of Prussian blue, which is here used to reproduce a nocturnal atmosphere (p. 35). It was the balance of the colours used that determined a print's quality.

The printing was not performed with a press; each picture was printed by hand, the printer rubbing the moistened paper in spiral movements as it lay

on the block, using an instrument called a *baren*; this often meant that the grain of the block is visible, thus adding a particular aesthetic charm (pp. 18,42). Register marks notched into the form allowed the paper to be placed accurately on each of the carved blocks, thus preventing unwanted colour overlaps. Hiroshige's landscapes placed the highest demands on the printers. One only has to think of his predilection for painterly colour washes (*bokashi*) to depict the sky or specific light and weather conditions. For every sheet, the printer had to smudge or dilute the pigment on the block in order to create the desired *bokashi* effects, for it was these that lent atmospheric depth to his landscapes. The highest degree of sensitivity was required here, which also explains why later reprints often differ from the first edition to such an extent that they are barely recognizable, if at all. Printers could also introduce three dimensional efforts by a form of embossing – by reversing the print and pressing out certain areas.

A good example of the technical quality of a first edition is the sheet *The Awa Whirlpool* from the series "Famous Views of 60-Odd Provinces" (*Rokujū yoshū meisho zue*) which appeared in 1855 (p. 40). The Straits of Naruto lie between the islands of Shikoku and Awaji in the north-east of Awa province. With the rapid change between the ebb and flow of the tide, the huge masses of water give rise to huge foaming whirlpools and waves that break against the cliffs. On the opposite bank lies the island of Awaji, whose grey silhouette stands out against the horizon in the evening light. Plovers are flying over the water. The deep blue at the top edge is characteristic of a first edition, thinning

Night Rain in Karasaki
From the series "Eight Views of Ōmi Province" (*Ōmi hakkei no uchi*), published by Eikyūdō (Yamamoto Heikichi), c. 1834
Colour print, ōban, 22.7 x 35.2 cm (8.9 x 13.9 in.), border preserved

Silhouette-like, the 1,000-year-old pine tree for which Karasaki was famous looms up from the evening haze behind a dense curtain of rain depicted by very fine lines. Some of the long heavy branches of the pine are supported by bamboo poles. In the foreground, bunches of needles take on clearer contours, while the details in the mid-distance and background come across as blurred, creating an impression of spatial depth. The reproduction of this moist atmosphere, dominated by pouring rain, placed the highest demands both on the carvers of the woodblocks, and on the printers, who had a decisive part to play in the interpretation of Hiroshige's composition through their controlled dilution and merging of the colours.

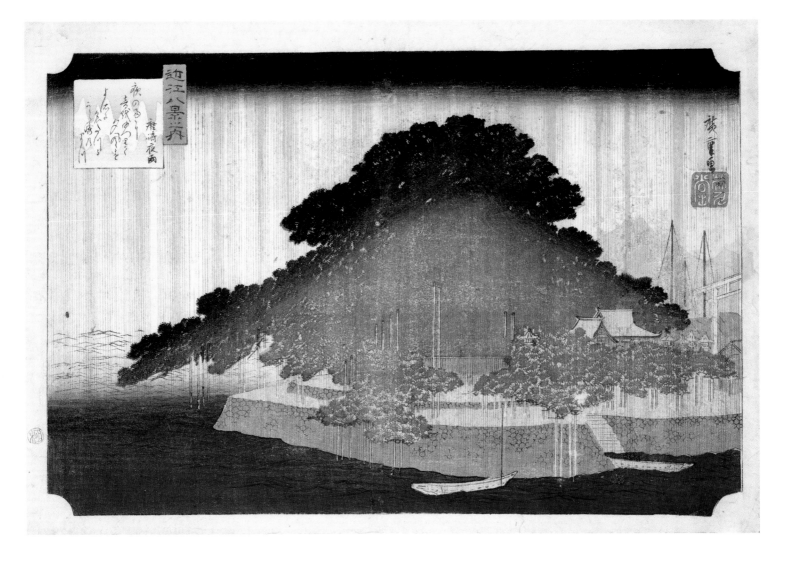

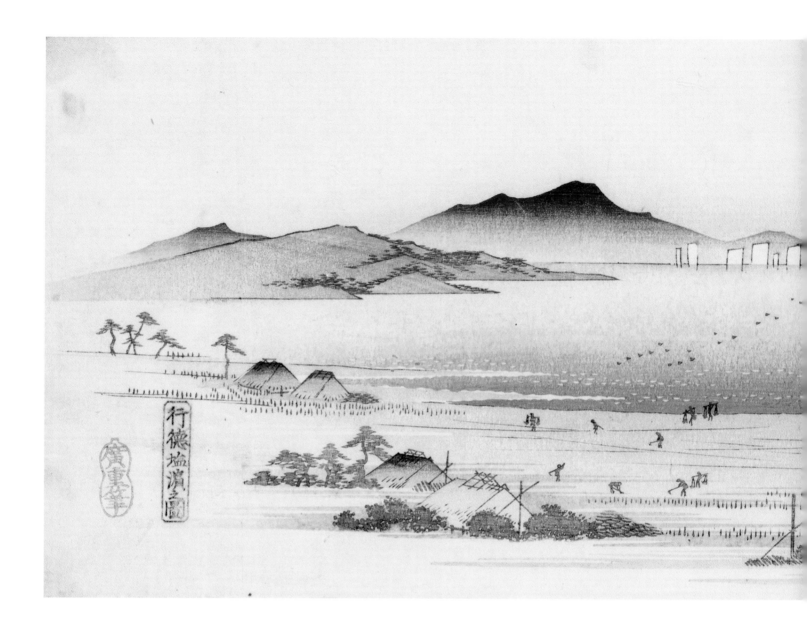

Salt Beach near Gyōtoku
From a series of 13 prints on writing paper titled "Famous Views in the Vicinity of Edo" (*Edo kinkō meisho*), published by Wakasaya Yoichi, c. 1840
Colour print, long horizontal ebangire, 15.5 x 45.5 cm (6.1 x 17.9 in.)

This rare print is in the style of a private edition, and was intended to serve as elegant writing paper. This is evidenced by the broad horizontal format and the pastel colours. At first sight one might think the print was a painting, so sensitive and differentiated is the modelling of the colours.

towards the horizon as a result of the *bokashi* effect; *bokashi* effects can also be seen at the bottom edge, on the crest of the wave and in the centre of the whirl-pool. The red on the ridge of the rocks is a strong russet which merges gradually with the grey of the rest of the rock. The red of the horizon is a strong red, and not orange as in later editions. The cartouche with Hiroshige's signature is prin-ted in red, the top left-hand corner having been left uninked by mistake, a fea-ture not seen in later editions. Such differences provide valuable insights into the printing process.

Technical sophistication of a different kind can be seen in the rare sheet of writing paper (*ehansetsu*) with the view of the Salt Beach (*Shiohama*) near Gyōtoku (pp. 44–45). Hiroshige did these views of the city of Edo and its sur-roundings for the publisher Wakasaya Yoichi in about 1840, but there is no pub-lisher's mark on this luxury print, which is in the style of the privately published poem and New Year's prints (*surimono*). On the right a dyke projects into the broad landscape, with peasants walking along it with their carrying rods. Below we can see accumulations of salt mounds, and on the beach the occasional peas-ant occupied with obtaining salt. On the far shore distant blue mountains are depicted against a delicate orange-red horizon. In view of the colour differen-tiation, one might at first glance think that this was a painting rather than a print. Hiroshige's contriburion to the technical and hence also the artistic

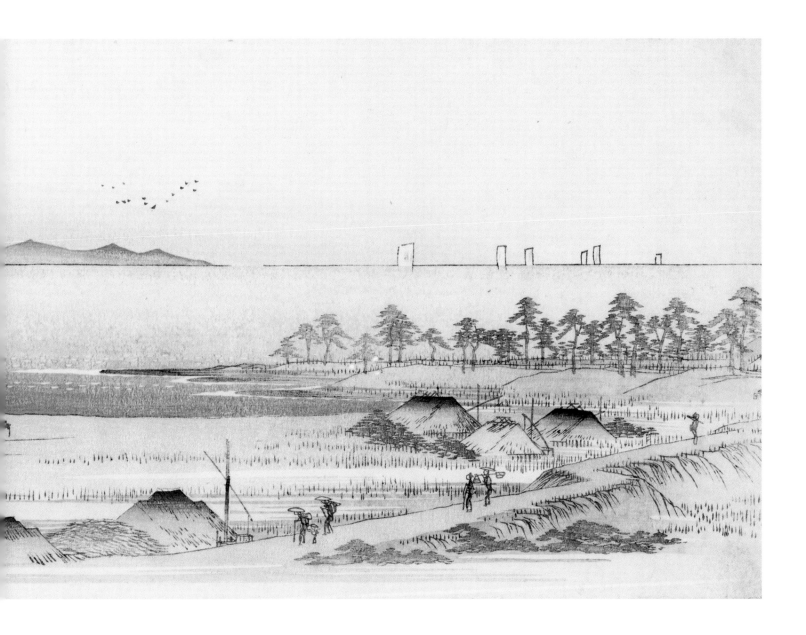

development of the colour print can hardly be exaggerated. He succeeded in
extracting totally new painterly qualities from this medium, a skill that was to
greatly enhance his appeal in a very competitive print market.

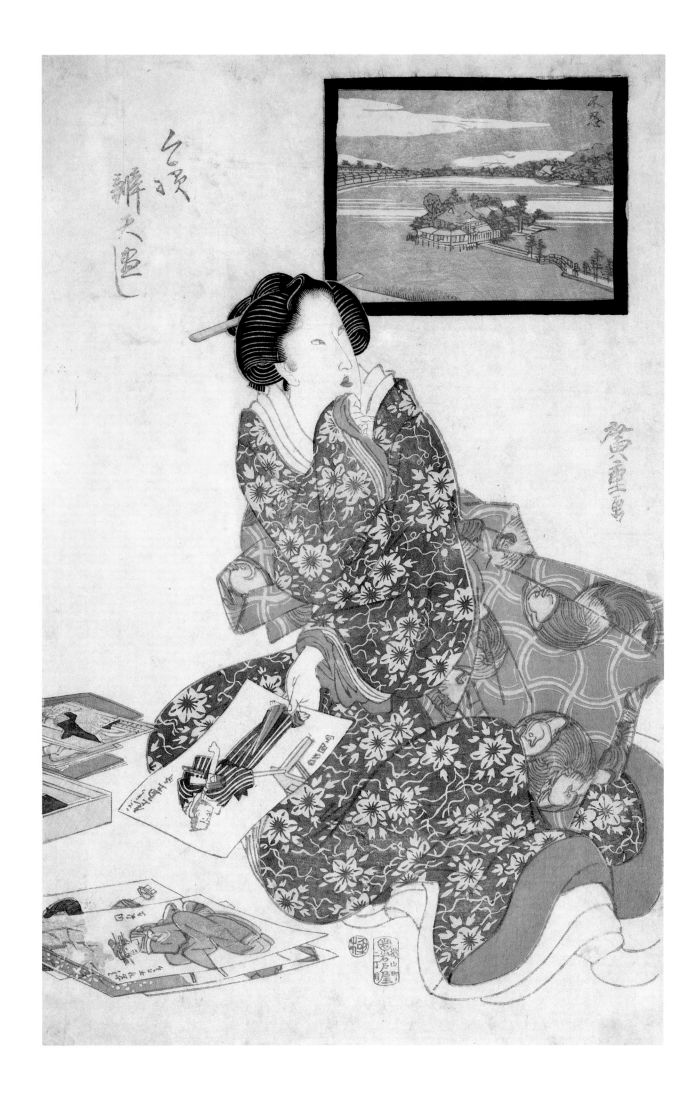

Hiroshige's Life

Hiroshige's birth-year can be worked out from his posthumous memorial portrait (p. 47), on which it says that he died at the age of 62, from which it can be calculated that in all probability he was born in 1797. Hiroshige's family had the surname Andō and were members of the samurai class. Thus Hiroshige is among the few woodblock-print artists who did not come from the milieu of craftsmen and the *chōnin*. His forename at first was Tokutarō, and later Jūemon, for it was traditional to change one's forename over the course of one's life, or to add new ones. His father Andō Genuemon had the hereditary post of a *hikeshi dōshin*, probably a fire warden, in Edo and as an official of the shogunate, will doubtless have drawn no more than a modest salary for overseeing the fire station in the city's Yayosugashi district. The fire station was in the heart of Edo in the neighbourhood now called Marunouchi. It also served as residence, not just for the Andō family, but also for the remaining 200 to 300 employees of the fire brigade.

Even before his death in 1809, Hiroshige's father had bequeathed his position in the fire brigade, which was doubtless more in the way of a sinecure, to his son. The same year, his mother died. Already as a ten-year-old, Hiroshige is said to have shown a talent for painting, and to have taken lessons from Okajima Rinsai, a painter in the style of the Kanō school, who likewise had a position at the fire brigade. In 1811 he was taken on as a pupil at the studio of the woodcut master Utagawa Toyohiro (1774–1829), after unsuccessfully seeking to be accepted by the more important Utagawa Toyokuni. After just one year's apprenticeship he was allowed to use the forename Hiroshige in 1812, and in addition a kind of studio name, Ichiyūsai, which he changed in 1830/31 by substituting a different character for the syllable *yū*, and again in 1832, this time to Ichiryūsai. In his signature seals, this name is occasionally abbreviated to Ryūsai. His teacher Toyohiro also had the studio name Ichiryūsai, albeit with a different character for the syllable *ryū*. Hiroshige thus perpetuated the name of his teacher. He also adopted the character for *hiro* from the name of his teacher Toyohiro as a sign of respect, combining it with *shige*, an alternative reading of the character for *jū* in his original forename Jūemon. This at first sight complicated approach to personal names, pseudonyms and studio names was an expression of the typically Japanese respect for one's teacher, and in this sense traditional, but it also reflected the idea of the name as programme, which could be adapted to the different phases of life as a kind of lucky charm.

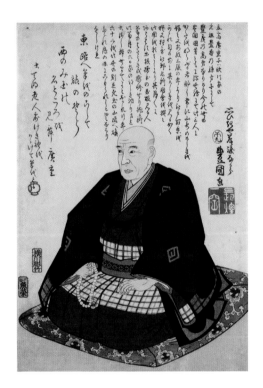

Toyokuni (Kunisada III)
Memorial Portrait of Ichiryūsai Hiroshige
With an obituary by his poet friend Tenmei Rōjin under the title "When we think of him, our tears flow" (*Omoe kiya raku rui nagara*) and Hiroshige's farewell poem, published by Uoei (Uoya Eikichi), dated 1858
Colour print, ōban, 37.5 x 25.8 cm (14.8 x 10.2 in.)

Courtesan Observing Prints
From the series "Benten Shrines at the Present Day" (*Imayō Benten zukushi*), published by Iwatoya Kisaburō, 1820–1822
Colour print, ōban, 38.6 x 25.9 cm (15.2 x 10.2 in.)

This print is among the rare early works of Hiroshige. A courtesan is holding in her hand a print depicting a man and bearing the signature of Toyokuni.

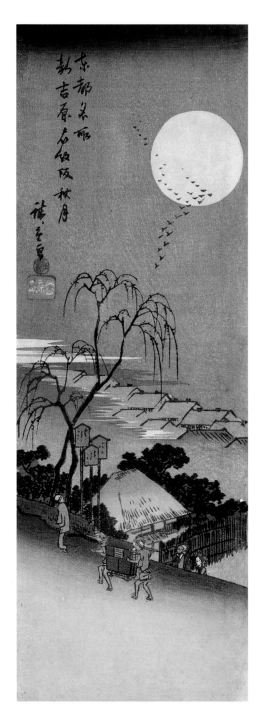

Autumn Moon over the Yoshiwara Quarter
From the series "Famous Views of the Eastern Capital" (*Tōto meisho*), published by Fujiokaya Hikotarō, late 1830s
Colour print, chūtanzaku, 35.2 x 12.4 cm (13.9 x 4.9 in.)

An affluent client is being carried in a litter down the steep slope after leaving the pleasure quarter. The man in front of him has stopped beneath a weeping willow in order to look back over the roofs of Yoshiwara. These weeping willows were also known as "looking-back willows". Like the skein of wild geese and the full moon, the motif of the weeping willow gives the scene a lyrically melancholy.

In his early days, Hiroshige, like his teacher, worked in the tradition of the Utagawa school. He designed workmanlike woodblock prints of beautiful women and Kabuki actors, as well as series of portraits of women and famous warriors, a genre which he continued to pursue later alongside his landscape prints (p. 46). In addition he illustrated several books, including a volume of comic poems (*kyōkabon*). All in all, his achievement to date did not point to any outstanding talent. But it may be that this can be explained by the fact that it was not until 1832 that he was able to free himself completely from the concerns of the fire brigade. He had already passed on the office in the 1820s to his son Nakajirō, who at that time was still a small child. The regular salary attached to his position maybe meant that he was not under particular pressure to concentrate on art to the extent of turning it into a livelihood.

The first great breakthrough was his series "53 Stations of the Tokaidō", which appeared between 1832 and 1834, with which he at once toppled Katsushika Hokusai (1760–1849), who was 37 years older, from first place in this genre. Without a doubt Hiroshige had been inspired by the "36 Views of Mount Fuji", with which Hokusai had created a furore in 1830. At the same time, Hokusai and Hiroshige were two fundamentally different temperaments, and it would be totally wrong to see Hiroshige as an imitator or "pupil" of Hokusai.

One might assume that Hiroshige often went on journeys to derive inspiration for his numerous landscape series. But this was evidently not the case. Certainly no original sources have survived that indicate this, and so most biographies are based, *faute de mieux*, largely on what we are told by Iijima Kyōshin in a work dating from 1894, which in turn relies only on unconfirmed statements by Hiroshige III (1843–1894). Modern studies have made it clear that for many of his compositions, Hiroshige was inspired by illustrated travel guides, which provides cause enough to question his actual travel activity. The journey from Edo to the old imperial capital of Kyoto, which he is said to have undertaken along the Eastern Sea Road in 1832 as part of an official delegation of the shogun, does seem though to possess a certain credibility, although it too has been questioned by a number of Japanese specialists. Every year the shogun sent two horses as tribute to the imperial court in Kyoto, which were presented to the emperor at a solemn ceremony on the 1st day of the 8th month. Hiroshige is said to have been commissioned to record the event in a picture. Actually such a commission should have gone to a painter from the Kanō school, which was officially protected by the shogun, especially as Hiroshige had completely resigned from his fire brigade post in the 3rd month of the same year, and thus no longer had any official connexions at all. That at least is the argument of those who cast doubt on this journey. On the other hand the date, 1832, fits only too well with that of his first series of the "53 Stations of the Tokaidō", which in the opinion of most scholars appeared between 1832 or 1833 and 1834 and could document his still-fresh travel experiences. However that may be, it is altogether probable that Hiroshige undertook a journey along the Eastern Sea Road in the early 1830s. His extant sketch-books suggest that he was anything but a studio painter, and liked to draw *en plein air* with a keen sense of observation. Even so it is important to be aware that most datings of his works are by no means certain, for only from 1849 onwards did the censors add a date stamp to their name stamp on the prints.

Hiroshige married twice. His first wife, whom he married in 1821, and who died in 1839, was the daughter of a fire brigade official named Okabe Yuaemon. In 1847 Hiroshige married a farmer's daughter named Yasu, who was 15 years his junior, and together in 1852 they adopted a daughter, Tatsu. Later she was to

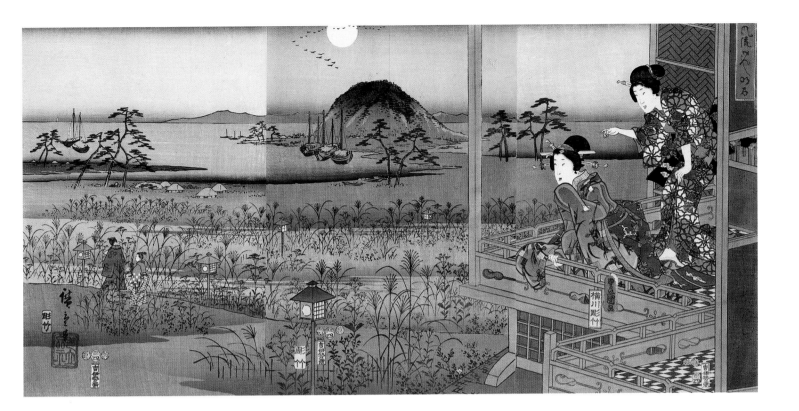

Akashi
From the series "An Elegant Story of Prince Genji"
Joint work with Toyokuni (Kunisada III),
published by Iseya Kanekichi, 4th month of 1853
Colour print, ōban, triptych, 35.6 x 73.2 cm
(14 x 28.8 in.)

By moonlight in the company of a young man-
servant, Prince Genji leaves the house of a lady
who, with her two maids, is following his depar-
ture with longing. The romantic scene is set on a
moonlit plain in which rows of grasses are ten-
derly contrasted with the grey and green shaded
ground. The figures are wearing the clothes of
the Edo period. The picture illustrates the fam-
ous novel *The Tale of Genji* (*Genji monogatari*),
written by Murasaki Shikibu at the beginning of
the 11th century. Hiroshige's friend Kunisada
was responsible for the depiction of the figures.

marry Hiroshige's pupil, Hiroshige II, only to divorce him to become the wife of
Hiroshige III. Of Hiroshige's marriage with Yasu it is known that she allowed
him an extravagant lifestyle and a great deal of creative space, which led to re-
peated financial difficulties, and brought him the nickname Shunei ("long day
in spring"). Hiroshige is said to have eaten well and drunk a fair bit. His unin-
hibited good living was altogether typical of the *chōnin* milieu.

In 1856, at the age of 60, Hiroshige took the tonsure and become a Buddhist
monk. According to the custom of the time, it was by no means unusual for ob-
servant Buddhists to take this step in preparation for their approaching end. Nor
did it involve turning one's back on the world or one's profession.

On the 6th day of the 9th month of 1858 Hiroshige died, probably one of the
victims of a cholera epidemic that claimed the lives of 28,000 people within a few
months. Three and two days before his death, respectively, Hiroshige made two
wills. The first reads:

"Sell the house and repay the money to Mr Sumihisa. Sell the books and the
household appliances and move to a different district. Take advice from others
on the distribution of the money. Everything depends on money, but as we do
not have much, I shall not lay down how you are to use it. You should proceed as
you see fit. Distribute my painting utensils, copies and sketches as mementoes to
my pupils. Give my clothes to Orin. As Shigenori (later Hiroshige II) has been
my pupil for a long time, he shall have one of my short swords.

Not just the affairs of the hell to which I am going, but also the affairs of this
world, depend on money."

In his second will Hiroshige starts by quoting the first line of the farewell
poem by the wife of Emperor Soga from the Heian period, who went down in
history as a great devotee of Zen Buddhism. Hiroshige's will begins:

"An old verse reads, 'When I die, do not burn or bury my body, but throw it
into a field and feed the hungry dogs.' In this sense give me a simple burial. But
since I live in the city of Edo without a field nearby where my body could be
thrown, bury me next to a temple. You needn't set up a headstone. Nor is there

any need for hot water to wash my corpse. But you should pour water over my body, so that it presents a decent appearance. At the temple the coffin will in any case be lowered into the ground and covered with clay, so that a meticulous cleansing would be a waste. As I have already taken the tonsure, a simple recitation of the sutras will suffice. But I should like to receive a posthumous Buddhist name with the syllables 'ingō'. Ask the temple what that costs and pay it. Miserliness is to be avoided, but so is waste. Hold a wake. I wish to be buried in the cemetery of the Asakusa Tōgakuji temple. Have a funeral as for a samurai. If you prefer a private ceremony, use the sashini style in place of the samurai style."

On the memorial picture (*shine*) that Hiroshige's friend Kunisada III (Toyokuni, 1786–1865) painted soon after his death, he is depicted with shaven head in the official costume of a *chōnin* sitting on a cushion (*zabuton*). He is wearing a blue kimono, with a check pattern around the middle with his family coat-of-arms, and a gauze cloak (*haori*) tied at the front. In his right hand he is holding the Buddhist rosary. Above Hiroshige's portrait is an obituary by his poet friend Tenmei Rōjin. The title is: "When we think of him, our tears flow." It is to the right of Toyokuni's signature and the seal *kien-ikkū*, which means, literally, "Clouds of incense ascend to heaven."

The obituary reads:

"Ryūsai Hiroshige is one of the outstanding successors of Toyohiro, who in his turn was a pupil of Toyoharu, the founder of the Utagawa school. In our day Hiroshige, Toyokuni III (Kunisada) and Kuniyoshi are regarded as the three great masters of ukiyoe; no one else can approach them. Hiroshige was particularly known for his landscapes. In the Ansei period (1854–1859) he painted the 'Hundred Famous Views of Edo', which provided a large number of admirers with a lively view of the landscape sceneries of Edo. During this period there also appeared a monthly picture series 'Comic Poems about the Famous Views of Edo' with illustrations by Hiroshige, in which he displayed his incomparable talent, much admired by all the world, in the use of the brush. He left this world on the

Dragon Emerging from the Clouds
No publisher's mark, c. 1850
Colour print, ōtanzaku, 37 x 17 cm (14.6 x 6.7 in.)

The rain-giving dragon as the symbol of heaven and the male Yang element testifies to Hiroshige's mastery of the Chinese style, as handed down by the Kanō and Tosa schools of Japanese painting.

Courtesan Holding a Hairpin
From a series of fan pictures "Goose-Borne Tidings" (*Kari no tamazusa*), publisher's mark not identified, c. 1853
Colour print, fan, 22.8 x 29.5 cm (9 x 11.6 in.)

An elegant courtesan pulls a hairpin from a paper wrapping – is it possibly a gift from an admirer with a promising letter? The pattern of her red-lined kimono and the elegant violet obi contrasts with the aubergine-red hemp-leaf pattern (*asa no ha*) that dominates the background. The hemp-leaf pattern, dyed using the wax-resist technique, represented a popular fabric design for women's magnificent under-kimonos.

6th day of the 9th month of this year at the ripe age of 62, leaving a will regulating his affairs, and a funerary poem. He set off on the laborious journey to the life beyond, where he is now in paradise. It grieves us to have to part from him."

The funerary poem (*jisei*) above left, mentioned by his friend, reads:

"I leave my brush on Azuma Street (in this world),
I go to see the famous views (*meisho*)
of the Western Paradise (of Amida Buddha).
Hiroshige
This was written by Tenmei Rōjin in deep grief."

The portrait by Kunisada represents the only known likeness of Hiroshige. The wrinkles on the forehead, around the mouth and around the eyes, like the striking nose, the sharply outlined mouth and the lively eyes reveal a wide-awake, discriminating and demanding old man. One can easily imagine his perfectionism and precision, but also his wit and his dry humour. Evidently this did not desert him even when writing his funerary poem, in which he alludes to the "famous views" (*meisho*) of paradise, which he, the painter and draughtsman, wishes to inspect.

Cherry Blossoms near Saga
From the series "Prince Genji in Snow, Moonlight and Flowers" (*Genji setsugekka*), published by Ibaya Senzaburō, 1st month of 1854
Colour print, fan, 21.5 x 29 cm (8.5 x 11.4 in.)

This fan print shows Prince Genji, the hero of the novel *The Tale of Genji* (*Genji monogatari*), in the spring at the time of the viewing of the cherry blossoms; he is dressed in the style of the Edo period. In the background can be seen the mountains of Arashiyama and the Tonase Waterfall to the north-west of Kyoto.

Series and Smaller Editions

In their attempt to determine the total number of Hiroshige's pictorial compositions, scholars come to varying results. Some experts talk of 8,000 compositions, while others put the figure lower, at between 4,500 and 5,000. But it is beyond dispute that Hiroshige was incredibly productive, above all when one considers how relatively limited his thematic spectrum was. For a standard edition, one can assume that between 10,000 and 15,000 prints were made, while "best-sellers" might have run to between 20,000 and 25,000.

The "53 Stations of the Tokaidō" – Tōkaidō gojūsantsugi

This was the series that laid the foundations for Hiroshige's fame; it was reprinted in countless editions, albeit of highly variable quality. Hiroshige edited the 55 sheets (including the first and last stations in Edo and Kyoto) at the publishing house of Hōeidō and Senkakudō as a "collection of pictures" (*gashū*), in other words the individual sheets were brought out in instalments probably between 1832 and 1834. The date of completion is beyond dispute, as it is confirmed by the epilogue. It is not however clear when he started the series, and the date of 1832 or 1833 has always been accepted on the understanding that it was inspired by his journey in the service of the shogunate, although as we have seen, there is room for doubt whether such a journey ever took place. The series may in other words have been started earlier than 1832 or 1833. Alongside new images, the famous "Hōeidō series" contains pictorial compositions that Hiroshige had taken from the illustrated travel literature and the tradition of painting in the Chinese and Japanese styles. What is striking above all, though, is his great stylistic and compositional variety and his wealth of ideas.

There are sheets with a cryptic composition. These include the view of the 11th station in Hakone (pp. 16–17), in which the *daimyō* procession moving down the slope is hardly discernible, as it is concealed between the bright colours of the rocks and the dots of vegetation, executed in black in the manner of Chinese ink paintings. In the view of the 17th station, Yui, looking from the Satta Pass to Kiyomi Bay and the snow-covered Mount Fuji, the viewer must study the composition very intensively before discovering, against the background of the grey-brown shaded rock face, the porter and the two travellers, in the top left of the picture, as they bend down nervously on their vertiginous perch over the abyss to catch a glimpse of the bay (p. 54). In the print illustrat-

Thunderstorm at Kameyama Station
The 47th station of the series "Famous Views of the 53 Stations" (*Gojūsantsugi meisho zue*) in vertical format, published by Tsutaya Kichizō, 1855
Colour print, ōban, 34.3 x 22.6 cm (13.5 x 8.9 in.), border preserved

Kinryūzan Temple in Asakusa
From the series "100 Famous Views of Edo" (*Meisho Edo hyakkei*), published by Uoya Eikichi, 1856
Colour print, ōban, 33.9 x 22.3 cm (13.3 x 8.8 in.), border preserved

The asymmetrically placed entrance gate to the Kinryūzan Temple and the paper lantern cropped by the top edge of the print form the visual frame through which our gaze is directed.

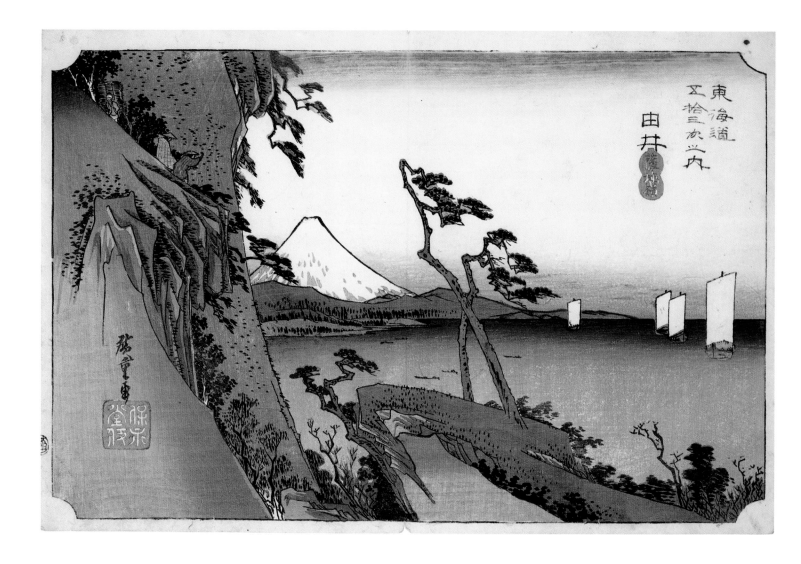

東海道五拾三次之内
由井
薩埵嶺

The Satta Pass near Yui Station
The 17th station from the series of the "53 Stations of the Tokaidō" (*Tōkaidō gojūsantsugi*), published by Hōeidō (Takenouchi Magohachi), 1832–1834
Colour print, ōban, 23 x 35 cm (9 x 13.8 in.), border preserved

If one regards the two travellers at the top left looking over the abyss as "hidden identification figures", the Satta Pass, which Hiroshige has dramatically staged against the backcloth of Kiyomi Bay with the majestic Mount Fuji in the background, comes across as all the more vertiginous.

ing the 47th station, Kameyama (p. 55), a *daimyō* procession is moving on a clear morning after a heavy snowfall up the steep pine-lined mountain slope to Kameyama Castle. In the dramatic, oblique way the picture has been "cropped", even part of the roof of the castle has been cut off, and the delicate yellow head-gear and heavy trunks only appear sporadically from behind the snow-covered cushions of pine needles. The coloration adds to the cryptic nature of the print. Evidently, the "hidden identification figures" and the surprise factor involved in their discovery were a means of captivating the viewer and drawing him or her into the composition.

In other prints in the series, the focus is on the unintended comedy with which people encounter wind, rain, snow and darkness, or else defy the heavy burdens they are forced to bear. This applies for example to the starting point in Edo, the Nihonbashi (p. 8), the 44th station near Yokkaichi (pp. 10–11), and the perspective view of the 30th Station, Hamamatsu (p. 57). Peasants are warming themselves in the early morning light by a fire at the foot of a pine tree. A traveller and a woman with a child on her back have joined them. One peasant is holding his hands in front of the fire, while another has pulled up his clothes to warm his back and backside. The plain, covered with light snow, is divided into two by the pine tree and the thick clouds of smoke in the foreground, while individual bare trees are discernible in the middle distance. Only vaguely visible on the horizon is the castle built in 1617 by Tokugawa Ieyasu, the founder of the Tokugawa shogunate. The desolate landscape arouses feelings of sympathy with the freezing people. If we assume that Hiroshige's contemporaries must have

known which castle it was, we can only be astonished by the coarse, untroubled scene, which makes the viewer the secret witness of this unconcealed disrespect towards, or at the very least, latent criticism of, authority. In general, any sign of social or political discontent was censored.

The 42nd station (p. 55 top) shows a religious spectacle at the Atsuta shrine in Miya, today's Nagoya, in which the sword, one of the three imperial regalia, is kept. In the glow of the nocturnal fire, two horses are being raced. The groups are wearing differently coloured cotton clothes. The men are gesticulating wildly, thrashing the beasts from behind with whips and clubs, while pulling on ropes at the same time to prevent them from bolting, for otherwise they would all be pulled to the ground and dragged along behind. The two-dimensional composition, cropped by the edges of the print, in which depth is suggested by the *torii* projecting into the picture at the bottom right and the buildings and onlookers visible behind clouds of smoke at the top left, is in the tradition of narrative painting in the Japanese style using the horizontal handscroll format.

The series also contains numerous broad panoramas and ends with the evening view of the Sanjō-Ōhashi Bridge over the Kamo River in Kyoto (p. 56), with Mount Hiei and the Higashiyama in the background. Individual travellers, porters and a *daimyō* escort are crossing the river. In later reprints, the expertly shaded grey of the dried up riverbed, criss-crossed by cracks, has disappeared, as has the hinted-at reflection of the light on the water, replaced by a monotonous blue. In this print, Hiroshige keeps to the tradition of the bird's-eye perspective and the dark-grey smudges to modulate the distant mountain

Umaoi (ceremonial horse-race*) in the Atsuta Shrine near Miya Station*
The 42nd station of the series "53 Stations of the Tokaidō" (*Tōkaidō gojūsantsugi*), published by Hōeidō (Takenouchi Magohachi), 1832–1834
Colour print, ōban, 22.7 x 35 cm (8.9 x 13.8 in.), edge cut

Clearing Weather after Snow at Kameyama Station
The 47th station of the series "53 Stations of the Tokaidō" (*Tōkaidō gojūsantsugi*), published by Hōeidō (Takenouchi Magohachi), 1832–1834
Colour print, ōban, 22.5 x 34.7 cm (8.9 x 13.7 in.), edge cut

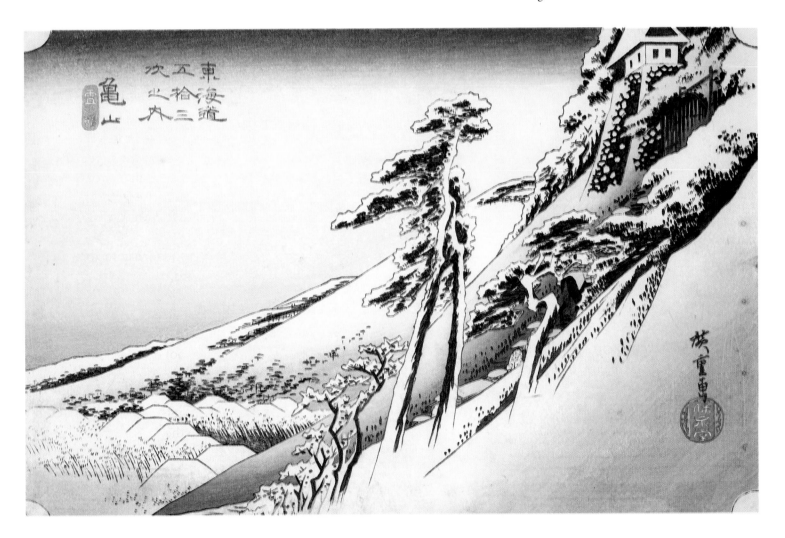

backdrop, and uses the bridge running diagonally across the picture to evoke spatial depth. At the same time, he devotes particular attention to the light falling from the west, and to its reflection, which reinforces the verist impression.

The theme of the 53 stations on the Tokaidō occupied Hiroshige time and again. And yet he presented the key motif of almost every station from a new angle every time. It also happens, though, that individual stations present totally new contents or aspects, and do not correspond in any way with the equivalent pictures in other editions. His ability to rework the same motifs many times without simple repetition is extraordinary.

Between 1839 and 1840, the "53 Stations" were published by Sanoya Kihei at the Kikakudō publishing house in combination with comic poems freely inserted in the composition. Although this edition has many a humorous scene to offer, the artistic quality is less convincing, and it is difficult to dispel the impression that Hiroshige was working somewhat hurriedly and without much dedication. The same is true of what is known as the Gyōsho Tōkaidō brought out by Ezakiya Tatsuzō between 1841 and 1842, so called because the series title is written in cursive script (*gyōsho*) in the rectangular red cartouches. But when one compares the inn scene at the 21st station (Mariko, p. 58), with the 54th station (Ōtsu, p. 59) in the later Reisho edition, the difference in quality is unmistakable The two prints display a similar composition, and provide the viewer with a bird's-eye view of an open street scene. In the 21st station, Mariko, in the Gyōsho edition we see two travellers, in a distinctly merry frame of mind, ad-

The Sanjō-Ōhashi Bridge in Kyoto
The final station of the series "53 Stations of the Tokaidō" (*Tōkaidō gojūsantsugi*), published by Hōeidō (Takenouchi Magohachi), 1832–1834
Colour print, ōban, 22.4 x 34.9 cm (8.8 x 13.7 in.), top border preserved

The final station on the Eastern Sea Road that linked Edo with the old imperial capital was the Sanjō-Ōhashi Bridge on Sanjō Street in Kyoto. The outstanding quality of this print in the Hōeidō edition can be seen in the *bokashi* effects in the depiction of the water and the dried-out sections of riverbed, and also in the differentiated modelling of the Higashiyama mountains in the background.

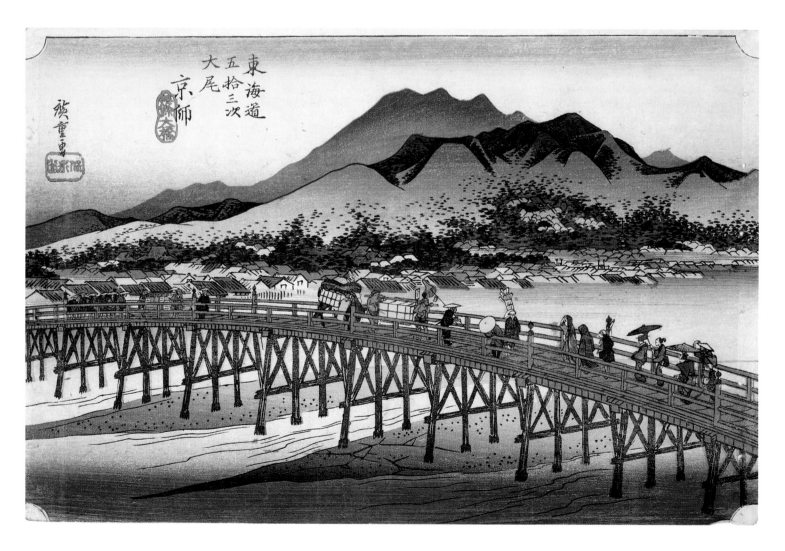

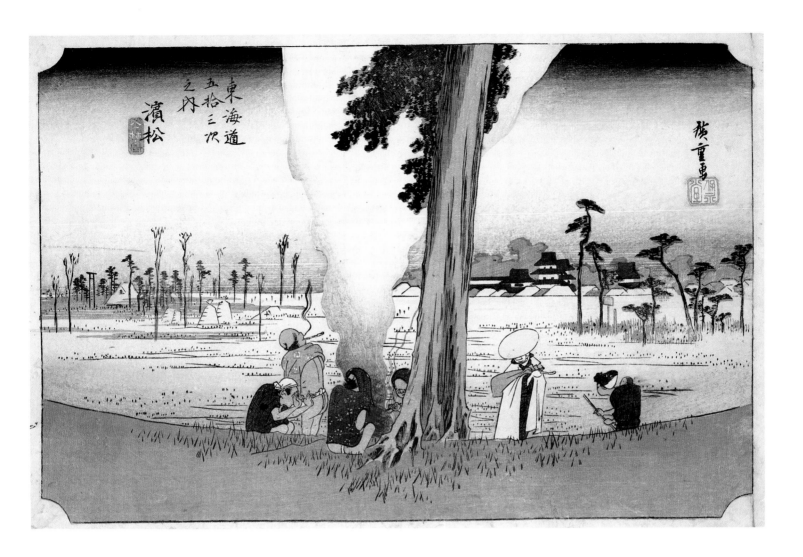

dressing the spicy *tororo* soup made from grated mountain yams (*tororo*) as advertised on the inn sign, while in the foreground we see plum blossoms, symbolizing springtime. The Reisho edition also shows a mundane street scene with a shop selling popular *ōtsu* pictures, and, on the other side of the street, quarrelling guests being ejected from an inn. The draughtsmanship and colour modulation in the Reisho edition, which was published between 1848 and 1852 by Maruya Seijirō, are far more demanding and therefore aesthetically satisfying. The series title also refers to the script in the red cartouche – here it is the official clerical script (*reisho*).

Between 1851 and 1852, the publisher Murataya Ichigorō printed what is known as the "Jinbutsu Tōkaidō", which, in respect of draughtsmanship and print quality is less convincing, but in which the figures are moved to the forefront of the pictures. Finally in 1855 the Tōkaidō was published in vertical format by Tsutaya Kichizō. This edition is distinguished in turn by its painterly, indeed often lyrical quality, but subordinates the figures to the landscape, which lends an impression of far greater physical and emotional distance. The contrast is clear if we compare the 1st station (Nihonbashi) from the first edition dating from the early 1830s (p. 8) with the version in vertical format from the 1850s (p. 23). A comparison of the Hakone station in the Hōeidō version (pp. 16–17), the Reisho edition (p. 18) and finally in the vertical format (p. 61) is also revealing, as are comparisons of the Yui station with the Satta Pass (pp. 54, 60 bottom) or Kameyama (pp. 53, 55) and not least the final station in Kyoto, the Sanjō-Ōhashi Bridge, in the various editions (pp. 56, 62, 63).

Wintry Desolation near Hamamatsu Station
The 30th station of the series "53 Stations of the Tokaidō" (*Tōkaidō gojūsantsugi*), published by Hōeidō (Takenouchi Magohachi), 1832–1834
Colour print, ōban, 22.7 x 34.8 cm (8.9 x 13.7 in.), border preserved

Peasants are warming themselves in the morning by a fire. One has pulled up his clothes to warm his back and his backside. The plain, covered by a carpet of snow, with individual bare trees, gives us an unimpeded view of the castle built by shogun Tokugawa Ieyasu in 1617, which is depicted only schematically, without sharp contours, on account of the distance. The coarse scene makes the viewer a secret witness of unconcealed disrespect for, or at the very least hidden criticism of, a government which in the mid 1830s had succeeded only with difficulty in putting down riots following a famine.

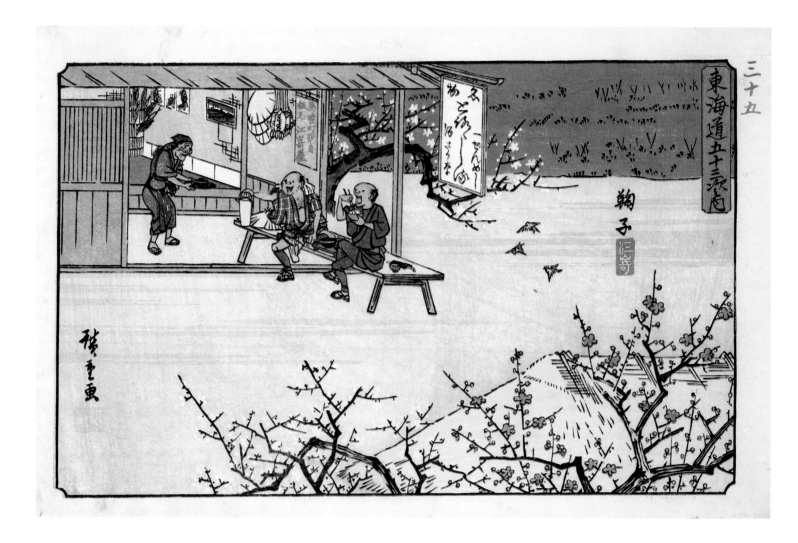

Mariko Station

The 21st station of the series "53 Stations of the Tokaidō" (*Tōkaidō gojūsantsugi*), published by Ezakiya Tatsuzō, Gyōsho edition, 1841/42
Colour print, aiban, 19.8 x 31.9 cm (7.8 x 12.6 in.), border preserved

In the Gyōsho edition, the viewer has a bird's-eye view of a street scene at the 21st station, Mariko. The plum-blossoms projecting into the composition indicate that it is springtime. On the opposite side of the road is an eating-house with an old wrinkled proprietress and two tipsy travellers enjoying a *tororo* soup made from grated mountain yams.

Other series

The "53 Stations", which first appeared between 1832 and 1834, was followed by series dealing with Edo and the "Famous Views of the Eastern Capital", the landscapes around Lake Biwa (*Ōmi hakkei no uchi*), dating from around 1835, represented in the present volume by the impressive sheet with the nocturnal rain in Karasaki (p. 43), and also by the outstanding series "69 Stations of the Kisokaidō" (*Kisokaidō rokujūkyūtsugi no uchi*), which appeared between 1837 and 1842, and in which Keisai Eisen (1790–1848) was initially involved. The series is exemplified here by the 19th station (Karuizawa, p. 65 bottom) and the 39th station (Agematsu, p. 64). A traveller on horseback arrives in Karuizawa in the evening, the township being hinted at by a few houses on the right of the picture and Mount Asama in the background. The groom lights his pipe from a fire, while the master gets a light from a passer-by. The fire, with its thick cloud of white smoke, partially illuminates the tree, while the paper lantern hanging from the saddle casts its light on some of the luggage as well as the face and shoulders of the traveller. The lantern is inscribed with the name "Iseri", a reference to the name of the publisher of this series, Iseya Rihei, whose company logo also adorns the saddlecloth. The example shown here is not just an outstanding early print with extremely subtle coloration, but it is also obvious that Hiroshige is playing in this sheet with chiaroscuro effects that bear witness to European influences. The Agematsu station (p. 64) shows pilgrims and a brushwood gatherer at a Shinto shrine. The way Hiroshige models the path with brown hatching in order to generate an impression of spatial depth again recalls

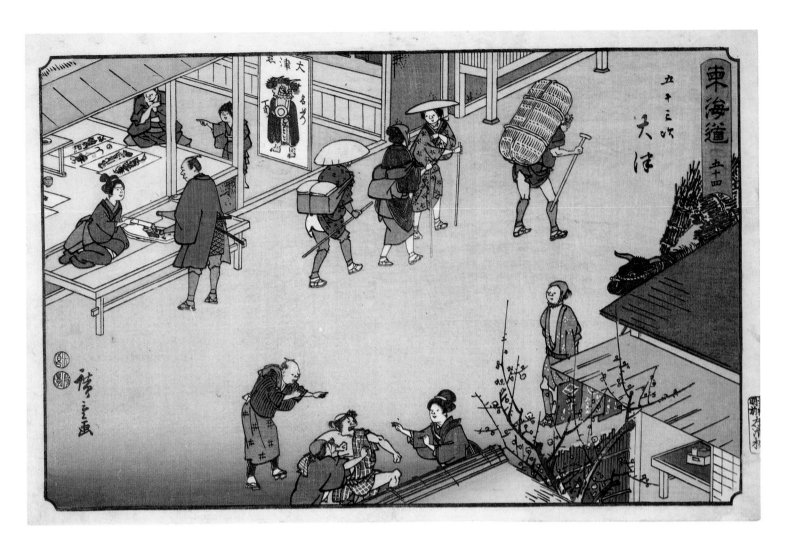

European copperplate engraving. In the time around 1834 there also appeared the "Famous Views of Kyoto" (*Kyōto meisho no uchi*; p. 9) and at about the same time the series of "Six Tama Rivers of Various Provinces" (*Shokoku mutamaga-wa*; p. 66).

Views of Edo

The numerous and varied series and triptychs with views of the capital Edo, which Hiroshige created from the early 1830s until shortly before his death, form, alongside the "53 Stations of the Tokaidō", the most important theme of his work. A good example of an early work from the series "Famous Views of the Eastern Capital" published by Kawaguchi Shōzō in about 1831 (*Tōtō meisho*) is the representation of people admiring the cherry blossom in Gotenyama (p. 24). It was presumably in the mid 1830s that Fujiokaya Hikotarō published the series *Tōto meisho* in the narrow upright *chūtanzaku* format. In its draughts-manship and style, the individual sheets are very variable: alongside experi-ments with Western central perspective (p. 34), the series also contains a lyrical view of the autumn moon over the brothel quarter Yoshiwara (p. 48). A well-heeled customer is being carried up a steep hillside in a sedan chair. The man in front has stopped beneath a bare willow and is looking back at the roofs of Yoshiwara. Weeping willows like these were also known as willows of looking back (*mikaeri yanagi*). This motif, like that of the wild geese in flight and the full moon, lends the scene a lyrical-melancholic atmosphere that was much ad-mired by Japanese print buyers.

Ōtsu Station
The 54th station of the series "53 Stations of the Tokaidō" (*Tōkaidō gojūsantsugi*), published by Marusei (Maruya Seijirō), Reisho edition, 1848–1852
Colour print, ōban, 22 x 34.8 cm (8.7 x 13.7 in.), border preserved

The Reisho edition also contains bird's-eye views of prosaic street scenes. A quarrelsome guest is being ejected from a tavern, and on the other side of the road travellers are looking at folksy *ōtsu* pictures. Compared with the Gyōsho edition, the print quality and the standard of draughtsmanship are considerably more de-manding and consistent.

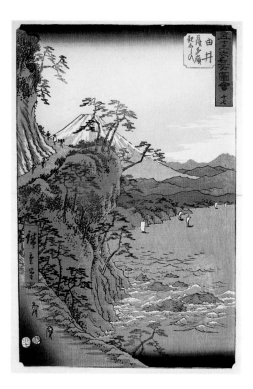

***Dangerous Place on the Satta Pass near
Yui Station***
The 17th station of the series "Famous Views of
the 53 Stations" (*Gojūsantsugi meisho zue*) in
vertical format, published by Tsutaya Kichizō,
1855
Colour print, ōban, 34.3 x 22.6 cm (13.5 x 8.9 in.),
border preserved

This print from the series of the "53 Stations of
the Tokaidō" in vertical format gives the viewer
the impression of a panorama of the whole Satta
Pass. The reticent coloration in blue and grey
tones and the differentiated modulation of the
cliffs, interacting with the delicate orange of the
evening sky, give the composition an impress-
ively painterly quality.

Yui Station
The 17th station of the series "53 Stations on the
Tokaidō" (*Tōkaidō gojūsantsugi*), published by
Marusei (Maruya Seijirō), Reisho edition, c. 1848
Colour print, ōban, 22 x 34.8 cm (8.7 x 13.7 in.),
border preserved

In the view of the Yui station in the Reisho edi-
tion, in contrast to the Hōeidō edition (p. 54),
Hiroshige's focuses our attention on the foot
of the gigantic mountain massif with the Satta
Pass and on the actions of the travellers.

PAGE 61:
***Nocturnal Journey in the Mountains near
Hakone***
The 11th station of the series "Famous Views of
the 53 Stations" (*Gojūsantsugi meisho zue*) in
vertical format, published by Tsutaya Kichizō,
1855
Colour print, ōban, 34.3 x 22.6 cm (13.5 x 8.9 in.),
border preserved

In contrast, Hiroshige's series "Famous Views of the Eastern Capital" (*Tōto meisho*), published in the late 1830s by Sanoya Kihei in horizontal format (p. 67) is decidedly verist. The latter focuses on the sober, detached observation of people in the anonymity of the crowd. In the series "Famous Views of Edo" (*Edo meisho*), published in 1853 by Yamadaya Shōjirō, the focus is once more on the figures, and here it is the tension between spectacular atmospheric landscape and the depiction of human "types" that gives the pictures their special charm (pp. 68 top, 69).

Hiroshige's "100 Famous Views of Edo" (*Meisho Edo hyakkei*), published between 1856 and 1858 by Uoya Eikichi, have become famous in the West not least through the copies made by van Gogh in 1887 of the Ōhashi Bridge in spring rain (p. 6) and of the admiration of the plum blossom in Kameido (p. 84). If there is such a thing as a hackneyed view of Hiroshige, then this series has surely contributed. The Ōhashi Bridge was built over the Sumida River in 1693; to the north stood the old Ōhashi Bridge, which was then renamed the Ryōgoku Bridge, which we have already met as the venue for a fireworks display. On the opposite bank Atake can be seen, with the shogun's boathouses. Six travellers have been surprised by a sudden summer shower. They are hurriedly seeking shelter beneath their hats and umbrellas. The rain, indicated by dense, ultra-thin, and in some cases intersecting lines, comes across like a curtain over the composition.

The plum orchard (*umeyashiki*) in Kameido on the west bank of the Sumida River was famous for the scent of one particular plum tree, known as "the plum of the sleeping dragon" (*garyūbai*). We see it in the foreground, and regard the scene behind through the bizarre network of its branches. The cropped notice-board top left is also supposed to give an impression of spatial depth. Some branches of this tree had got out of control, layering themselves by putting down new roots in the ground, from which in turn new branches grew, forming a huge, peculiar structure, reminiscent of a sleeping dragon, and regarded as a symbol of unbroken vitality. In the background beyond the fence men can be seen strolling. Of particular charm are the colours of the sky, running from red into pink, and the branches, modelled in grey and brown.

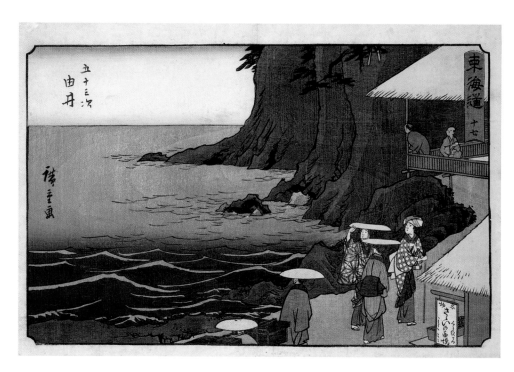

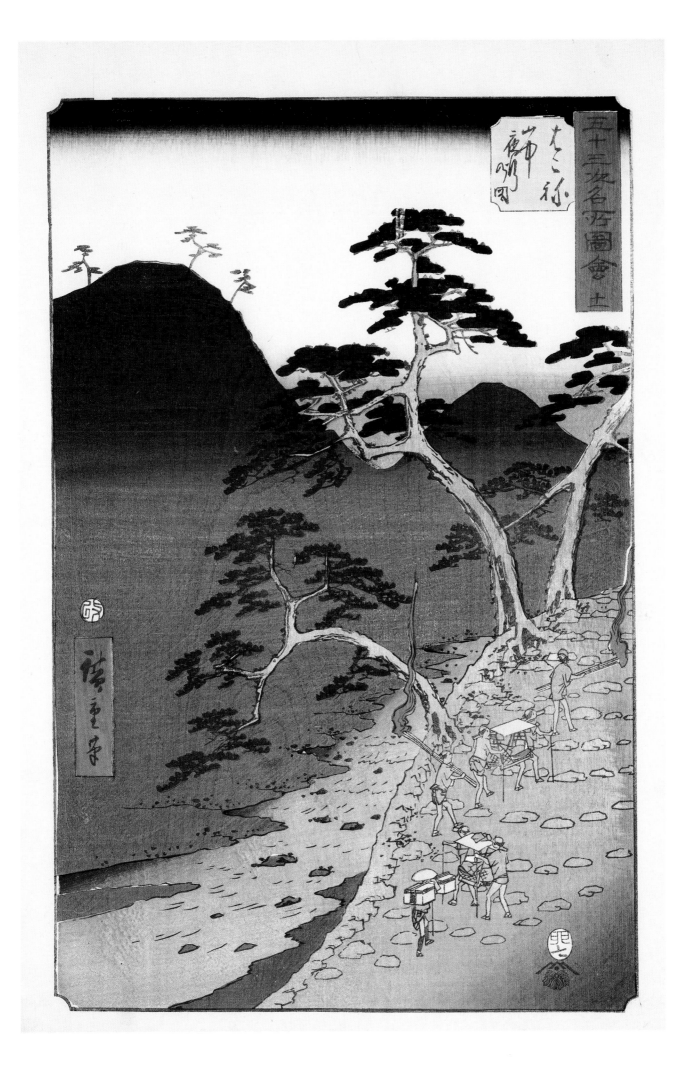

A similar compositional schema, with a main motif placed dramatically in the foreground, can be found in numerous prints in this series, for example the temple gate and lantern in a view of the Kinryūzan Temple (p. 52) and the balustrade of the Nihonbashi Bridge (p. 22), behind which the actual subject or landscape appears as a distant backcloth.

The series contains further breathtaking prints, for example the view of Matsuchiyama Hill and the Sanya Canal (p. 71). In the foreground, a geisha is following a paper lantern only partly visible on the left-hand edge of the picture. Purposefully, she moves along the bank of the Sumida River, in the background Matsuchiyama Hill, plunged in nocturnal darkness, with the Shōten shrine and some brightly illuminated restaurants at its foot. The colour transitions between blue and black, the stars and their reflection in the water, the cropped lantern on the left and the cropped cherry tree on the right, but above all the dignified posture and the determined gaze of the woman, who is depicted in profile, and whom Hiroshige has deliberately not placed in the centre of the picture so as to reproduce the momentum of her purposeful stride, make this print a masterpiece as mysterious as it is unforgettable. Moreover, it is the only one in the series to feature a large-size figure.

The "foxfires" on New Year's night beneath the *enoki* tree in Ōji (p. 70) create its mysterious effect in a quite different way, for here Hiroshige dramatically stages a legend. This picture was printed as early as the 9th month of 1857, but forms the last print in the series in today's conventional numbering, which was decided on retrospectively to maintain the order of the seasons. On a clear,

The Sanjō-Ōhashi Bridge in Kyoto
The final station of the series "Famous Views of the 53 Stations" (*Gojūsantsugi meisho zue*), vertical format, published by Tsutaya Kichizō, 1855
Colour print, ōban, 34.3 x 22.6 cm (13.5 x 8.9 in.), border preserved

In the 1855 vertical-format version, Hiroshige confronts the viewer with a detached, but at the same time atmospherically lyrical view of the Sanjō-Ōhashi Bridge, while pink and violet cloudbanks evoke spatial distance and harmonize in colour with the springtime cherry blossoms on Mount Higashi.

The Sanjō-Ōhashi Bridge in Kyoto (right) *and the Bank of the Kamogawa River with Restaurants at the Level of Shijō Street* (left)
The final station of the series "53 Stations" (*Gojūsantsugi*), of the so-called "Tokaidō with Figures" (*Jinbutsu tōkaidō*), published by Murataya Ichigorō, 1852
Colour print, chūban, 22 x 16.7 cm (8.7 x 6.6 in.), border preserved

Suhara

The 40th station of the series "69 Stations of the Kisokaidō" (*Kisokaidō rokujūkyūtsugi no uchi*), published by Kinjudō (Iseya Rihei), 1837–1842
Colour print, ōban, 22.5 x 35 cm (8.9 x 13.8 in.), border preserved

Travellers are seeking shelter from a sudden shower beneath the roof of a little Shinto road-side shrine. Two Buddhist pilgrims with the typical beehive-shaped headgear are already sheltering. Another traveller has unpacked his writing utensils and is writing his name on the posts of the shrine in memory of his weather-enforced visit, while two samurai with swords are still trying to reach the shelter of the roof.

Karuizawa

The 19th station of the series "69 Stations of the Kisokaidō" (*Kisokaidō rokujūkyūtsugi no uchi*), published by Hōeidō (Takenouchi Magohachi) and Kinjudō (Iseya Rihei), 1837–1842
Colour print, ōban, 22.6 x 34.8 cm (8.9 x 13.7 in.), border preserved

A traveller on horseback arrives in Karuizawa in the evening. The groom lights his pipe on a fire, while the gentleman gets a light from a passer-by. The fire with its cloud of thick white smoke partly illuminates the tree, and the paper lantern hanging from the saddle lights up in turn a part of the baggage as well as the shoulders and face of the rider. Hiroshige's play with light effects was without a doubt inspired by Western copperplate engravings.

Agematsu

The 39th station of the series "69 Stations of the Kisokaidō" (*Kisokaidō rokujūkyūtsugi no uchi*), published by Kinjudō (Iseya Rihei), 1837–1842
Colour print, ōban, 22.4 x 35.3 cm (8.8 x 13.9 in.), border preserved

Using hatching typical of Western copperplate engraving, Hiroshige lends spatial depth to the path to the waterfall, which is identified as a Shinto sanctuary by the little wooden shrine.

starry, frosty night, pale foxes have gathered around a lonely, bare Chinese hackberry (*enoki*) tree. Their pale breath resembles the will o' the wisp. Further groups of foxes with flaming breath are coming from the temple shrine of the rice deity Inari of Ōji, concealed among pines in the distance. According to an ancient legend, the foxes, armed with magic powers and sacred to Inari, gather on New Year's night at the *enoki* tree of Shōzoku. Peasants believed that the behaviour of the firefoxes predicted whether or not there would be a good harvest.

Flowers, birds, fish and other beasts

Alongside the landscape prints, in the 1830s Hiroshige composed outstanding prints on the subject of flowers and birds as well as two series with fish (p. 39), and in addition figure triptychs (pp. 49, 74–75, 86–87) and a steady stream of fan pictures (pp. 35, 50, 51). The stylistic variety of his nature studies is amazing. The cuckoo in the summer rain, printed around 1840 by Wakasaya Yoichi at the Shōeidō publishing house (p. 73 right), is a typical example of Hiroshige's keen observation of nature in the tradition of the Maruyama Shijō school, which in turn was inspired by European influences. The bird is not outlined by a continuous contour; rather, the body and plumage are modelled and structured by the colour and by black or grey hatching. The diagonal composition, with "rain threads" left uncoloured on the white paper and a picturesque, green-over-printed pine branch, whose grey shadow makes it stand out from the ground, and which alone takes up the whole of the bottom right-hand corner, is a dramatic trick in the bird's-eye perspective to draw the gaze of the viewer across the treetops into the expanses of the sky. The poem reads: "The two-tone call is audible over countless peaks – the cuckoo." Decoratively staged and more stylized, by contrast, are the two frogs beneath a branch with yellow yamabuki roses projecting diagonally into the picture from the top left, which is given a feeling of spatial depth by the finely gradated colours and individual internal lines (p. 72 right).

The two mandarin ducks beneath falling leaves (p. 73 left) date from about the mid 1830s. The poem "For the mandarin ducks the thin ice is a wedding blessing for a thousand years" alludes to the traditional symbolism, originating

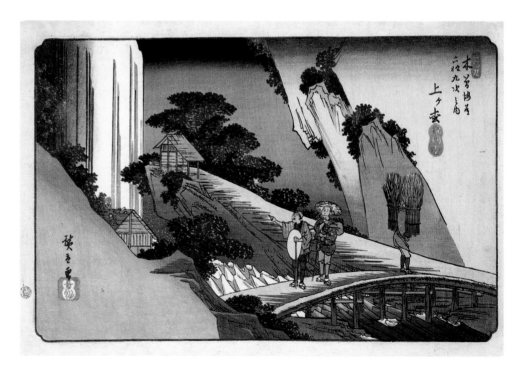

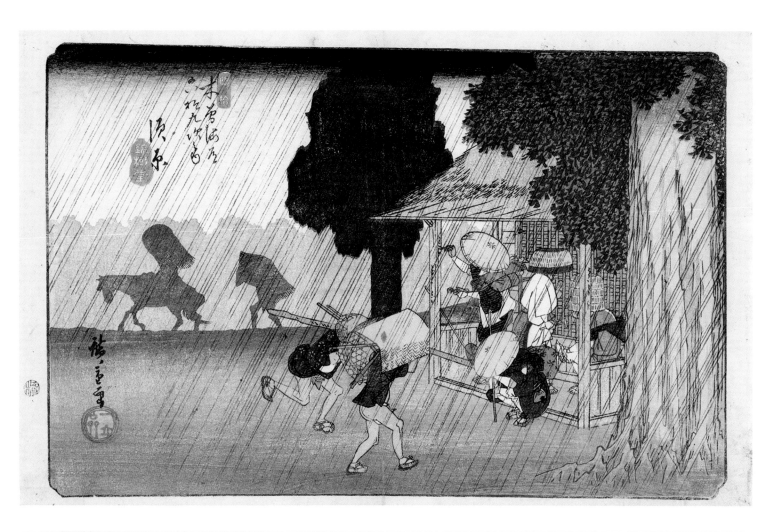

The Chōfu Tama River in the Province of Musashi
From the series "Six Tama Rivers of Various Provinces" (*Shokoku mutamagawa*), published by Tsutaya Jūzaburō, c. 1835/36
Colour print, ōban, 22.5 x 34.8 cm (8.9 x 13.7 in.), border preserved

In this landscape with its perspective structure, foreground, middle distance and background are very deliberately marked out by the two groups of washerwomen and Mount Fuji.

in China, of the mandarin ducks as standing for marital harmony. The verist depiction of the typical movements and the plumage of the ducks, and the delicate cracks in the thin ice, as well as the momentum of the leaves as they fall from the tree, all make the picture a lively, naturalistic image, which transcends the traditional symbolism.

The crane too (p. 72 left) has a symbolic meaning, and embodies not only longevity but also virtue, since, according to Confucian tradition, it settles only in places where virtuous people are to be found. In connexion with the rising sun, it appears here as a harbinger of happiness in the new year. But in his observation of nature, for example in the depiction of the bird's posture on a small tongue of land washed by the water, and in the masterly blue shading of the wave, Hiroshige once more goes far beyond the traditional symbolism. The painterly representation of the imposing dragon, dated to the 1850s, rising out of dense clouds of haze, a symbol of the male Yang element (p. 50), is once more back in the tradition of Chinese ink painting as perpetuated by the Kanō and Tosa schools.

Figures, shadow pictures and caricatures
The triptych with Taira no Kiyomori who sees supernatural phenomena (*Taira no Kiyomori kaii o miru zu*), particularly impressive on account of its surreal character, is presented here as an example of Hiroshige's skill in the rendering of figures (pp. 74–75). It dates from about the mid 1840s. In the 12th century, two important clans, the Taira and the Minamoto, were struggling for hegemony in

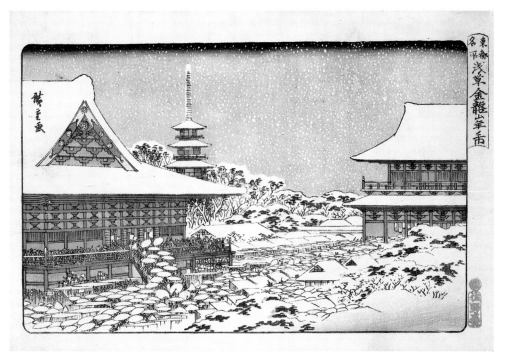

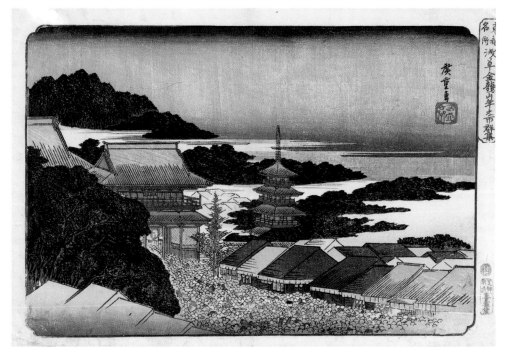

the country. Taira no Kiyomori, who was known for his brutality and cruelty, conquered the Minamoto. Towards the end of his life, though, it is said that his cruel deeds gave him hallucinations: stones, bushes and trees are supposed to have appeared to him as ghosts of the skeletons and death's heads of his victims. Hiroshige has represented this episode as a garden of boundless horror. Against an icy sky with clouds scudding across it, skull upon skull of various sizes, only recognizable as such on closer inspection under the heavy layer of snow, group themselves around a grey-blue lake. The soul of the cruel hero is gripped by fear and depression, which cannot be banished from the luxuriously appointed but ghostly villa. Such historical subjects could sometimes be seen as having a contemporary political significance.

In addition, Hiroshige's hitherto underestimated comic pictures deserve more attention, including the series "Improvised Shadow Pictures" (*Sokkyō*

Sunrise at New Year near Suzaki
From the series "Famous Views of Edo" (*Edo meisho*), published by Yamadaya Shōjirō, 1853
Colour print, ōban, 21.8 x 34.4 cm (8.6 x 13.5 in.), border preserved

The sun, and in particular the sunrise, are seen in Japan as symbolic of the New Year and of a new beginning. Very early, the warmly wrapped-up women have set out in the snow to be present at the sunrise, one of nature's dramas.

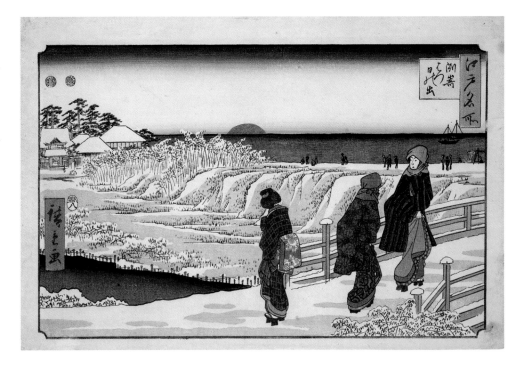

Mount Atago in Shiba
From the series "Famous Views of the Eastern Capital" (*Tōto meisho*), published by Sanoya Kihei, late 1830s
Colour print, ōban, 22.2 x 34 cm (8.7 x 13.4 in.), border preserved

Mount Atago with its Atago shrine was a popular destination for trippers and provided an outstanding view of the city of Edo. This print focuses on its famous tea-house, which provided visitors with a cool place to sit in summer.

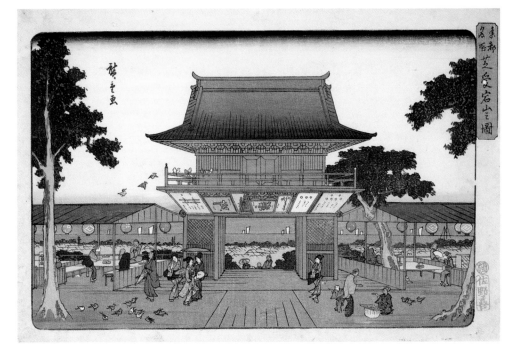

kageboshi zukushi) dating from the early 1840s, and his caricatures, nearly all of which also appeared in the 1840s, in which not only his inimitable humour finds expression, but also his importance for the modern Japanese comic (*manga*). In Japanese, these depictions are regarded as "playful pictures" (*giga*), an allusion to their humorous or satirical character. In this spirit, Hiroshige signed the series of shadow pictures "Hiroshige with playful brush" (*Hiroshige zarefude*). One print (p. 76 top) shows a man with a broom and shells (?) on the backs of his hands in a daring pose on a stool; in the corresponding shadow picture one can see, behind the sliding door (*shoji*) with its paper "panes", a junk with two oarsmen. In the scene below, he has a basket on his head: the corresponding silhouette gives him the appearance of a bowl on an oversize saucer with a splayed foot. Possibly it was a triptych by Kikugawa Eizan (1787–1867) which inspired Hiroshige to create his witty shadow pictures. Eizan shows three

geishas in casual pose who have gone outside to get some fresh air during a drinking party. On the brightly lit sliding doors behind them one can see in great detail the shadows of their elegantly dressed colleagues inside, one being caught in the act of adjusting a long hairpin in her fashionable hair-do. Hiroshige's use of this "play of shadows" exploits its humorous potential to the full.

Alongside the shadow pictures, Hiroshige's caricatures are also fascinating. One print (p. 77) shows two grotesque scenes: above, two blind masseurs who have suffered a misfortune. They had sat down at a street kiosk to enjoy a *kuzu* soup. As they get up to leave, one has by mistake got the corner of his robe caught on the edge of the table, but not realizing this, he has exposed his bare backside. What's more, the table has been overturned, while the ashtrays and charcoal dish on the tray for smokers' requisites have fallen down and singed the beard of the other blind man, who is lying screaming on the floor. In the scene below, the fat-bellied Buddha is laughing while a hypocritical fox, playing the Buddhist preacher, is addressing a gullible swollen toad and a stupid fat fish, who, both in ceremonial costume, are listening spellbound and have piled a respectable number of banknotes in front of the fox – the price of the edifying sermon.

Another print (p. 76) shows at the top a bookkeeper, who has fallen asleep over the book on his cabinet, and to his right a shelf with invoices. From his heart has emerged a huge "dream bubble", which reveals his secret desires: not only an elegant lacquered desk with dishes and boxes for high-class food and drink, but also the corner of a red futon jutting from behind a screen, a hint

Nihonbashi Bridge and Edobashi Bridge
From the series "Famous Views of Edo" (*Edo meisho*), published by Yamadaya Shōjirō, 1853
Colour print, ōban, 22 x 34.3 cm (8.7 x 13.5 in.), border preserved

The area around the Nihonbashi Bridge is still bathed in the delicate pink of dawn, but courtesans and porters are already out and about.

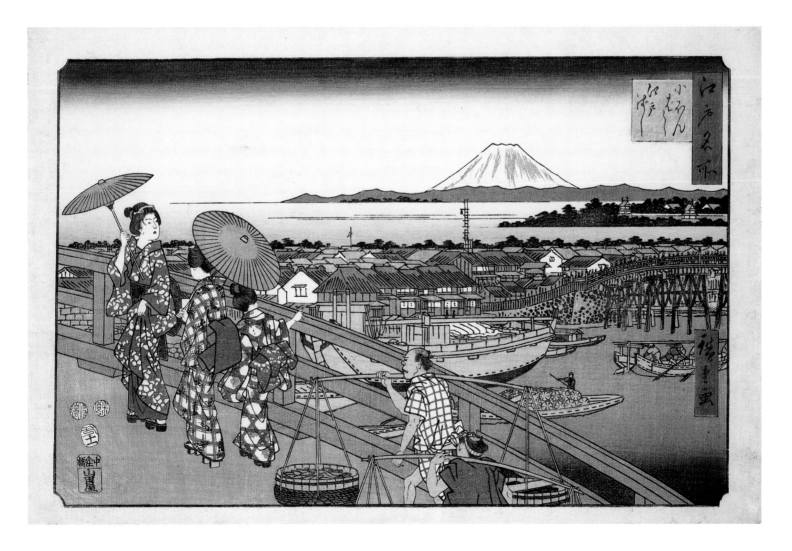

Foxfires on New Year's Night beneath the Enoki Tree
From the series "100 Famous Views of Edo" (*Meisho Edo hyakkei*), published by Uoya Eikichi, 1857
Colour print, ōban, 33.7 x 22.5 cm (13.2 x 8.9 in.), border preserved

On a starry, frosty night, foxes have gathered around a lone, bare Chinese hackberry (*enoki*) tree. The bright breath of each resembles a will o' the wisp. Further groups of foxes with flaming breath are approaching from the shrine of the rice deity Inari at Ōji. According to an ancient legend, foxes with magic powers sacred to the rice deity assembled on New Year's night beneath the *enoki* tree at Shōzoku.

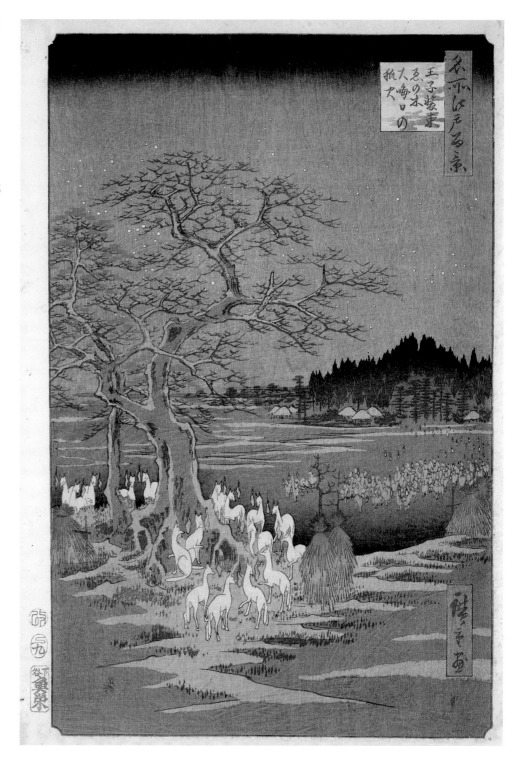

PAGE 73 LEFT:
Pair of Mandarin Ducks on Ice
No publisher's mark, mid 1830s
Colour print, chūtanzaku, 36.9 x 13 cm (14.5 x 5.1 in.)

Mandarin ducks were traditionally regarded in China as the symbol of marital harmony. The verist depiction of the ducks, the thin, cracked ice and the falling autumn leaves are however the result of close observation of nature and transcend the good-luck symbolism.

that he is dreaming of a night in a brothel. An apprentice has crept up, and with a grin has painted two strokes over the bookkeeper's brows, standing for the character for the number eight (*ba*). In the scene below, two schoolboys are playing a trick on their teacher, evidently a proud samurai with a short sword in his belt. The school benches are still piled up, while an exercise book for calligraphic practice is hanging on a stick. A scrap of paper has been torn out of the cover as a nose, and a ghost-face has been painted on it. The textbook, in the form of a folding scroll, has been draped over his back by one of the boys so cleverly that together with the clownish face it comes across as a dragon or as a ghost in the form of a snake. The intrepid teacher has got such a fright that he falls screaming to the floor. By this time, the samurai had largely lost their role in society and were sometimes seen as figures of fun.

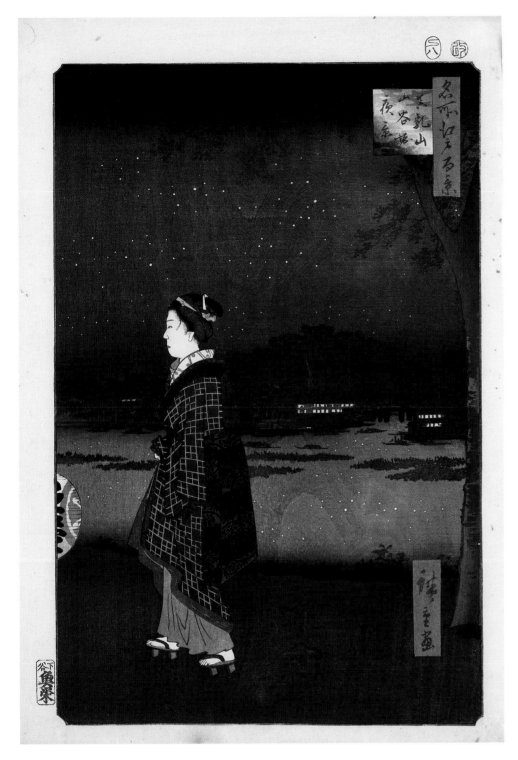

Evening View of the Sanya Canal and Matsuchiyama Hill
From the series "100 Famous Views of Edo" (*Meisho Edo hyakkei*), published by Uoya Eikichi, 1857
Colour print, ōban, 34.1 x 22.7 cm (13.4 x 8.9 in.), border preserved

In the foreground on the left, a geisha is following a partially visible paper lantern. She is walking purposefully along the bank of the Sumida River, while in the background we can see, shrouded in darkness, Matsuchiyama Hill, and at its foot the Shōten shrine and some brightly lit restaurants. The colour transitions between blue and black, the stars and their reflection in the water, the cropped lantern on the left and the cropped cherry tree on the right, but above all the dignified attitude and purposeful look of the woman depicted in profile, make this print a masterpiece as mysterious as it is unforgettable.

The triptych (pp. 78–79) of the war between rice-wine (*sake*) and rice-paste cakes (*mochi*), in other words between the alcohol camp and the confectionery camp, conceals a humorous pun. All the varieties of containers for *sake* – barrels, bottles, calabashes etc. – which each have a precise designation, have gathered as a colourful horde of samurai warriors. They have declared war on the rice-cakes of whatever shape and taste, likewise designated by their names in cartouches, and beautifully packaged, for example in a bamboo leaf. To the sides, we see boards with the names of the shops supplying specialities in the field of *sake* or *mochi* respectively. The title in the cartouche on the central sheet reads: "Taiheiki mochi sake taku taku mai" and could be translated approximately as "Joy over the great peace between *mochi* and *sake*: buy more, buy more!" The term "taiheiki" alludes to the martial epic of the same name, the *Chronicle*

PAGE 73 RIGHT:
Cuckoo in Summer Rain over Isozaki
Published by Shōeidō (Wakasaya Yoichi), c. 1840
Colour print, chūtanzaku, 38 x 12.8 cm (15 x 5 in.)

The body and plumage of the cuckoo are modelled by the colour and by black or grey hatching. The diagonal composition with "threads of rain" left bare by the printer and a picturesque branch of a pine tree, overprinted in green, set off from the background by grey shadows, directs the gaze of the viewer across the tree-tops and away into the distance. With a great gift for observation, Hiroshige has captured the flying movement of the cuckoo precisely.

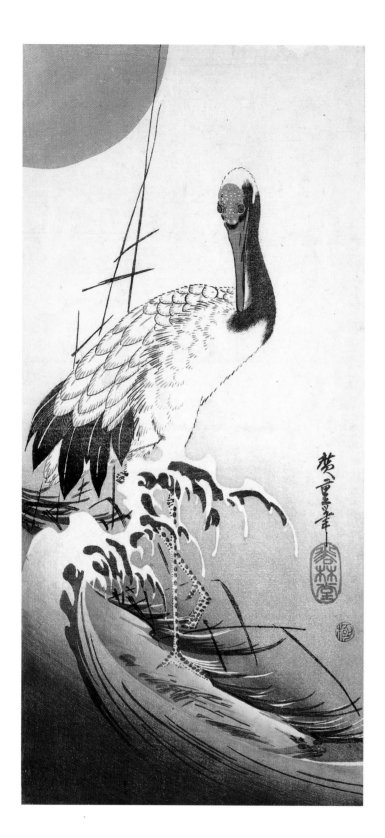

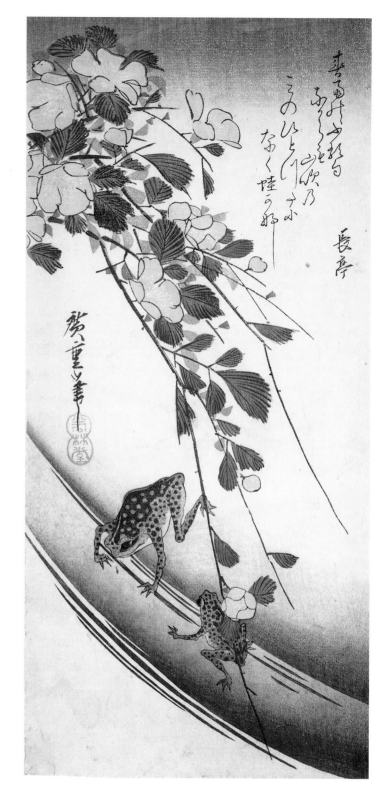

Crane at Sunrise
Published by Yakurindō (Wakasaya Yoichi), c. 1832
Colour print, ōtanzaku, 38.6 x 17.5 cm
(15.2 x 6.9 in.)

In combination with the rising sun, the crane
appears as a lucky New Year messenger.

TOP RIGHT:
Frogs and Yamabuki Roses
Published by Yakurindō (Wakasaya Yoichi), c. 1832
Colour print, ōtanzaku, 38.6 x 17.8 cm (15.2 x 7 in.)

of the Great Peace", which describes the conflict between the northern and
southern courts in the period from 1318 to 1367 and ended with the victory of
the Ashikaga shoguns. The title of the epic, which was written around 1370, thus
expressed the hope of an end to the conflict and the dawn of an age of peace.
Hiroshige has made a witty pun of this, replacing the character *ki* (= chronicle)
by the character for the homophone *ki* (= joy) and thus satirizing the rivalry
between the *sake* and *mochi* dealers. Punning of this kind was a popular feature
of Japanese literature and art.

We should also mention the many so-called *harimaze* prints (p. 15) created
between 1848 and 1852. In these "mixed pictures" he unites various views and

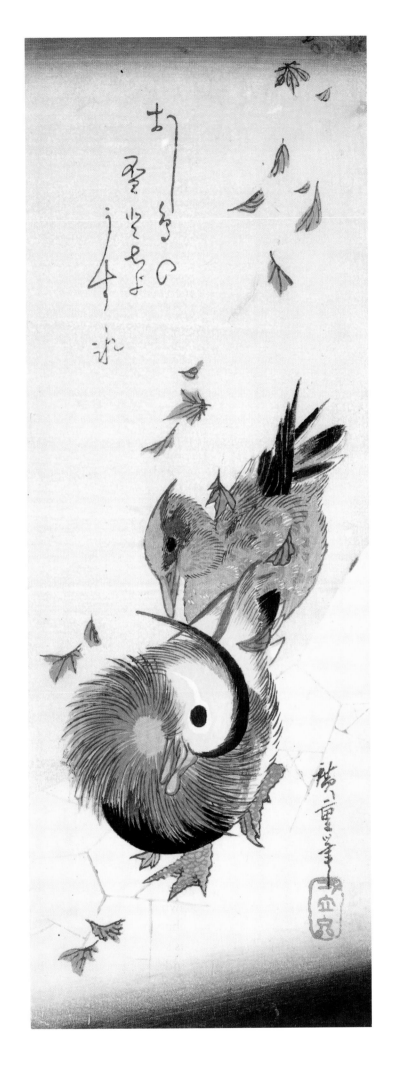

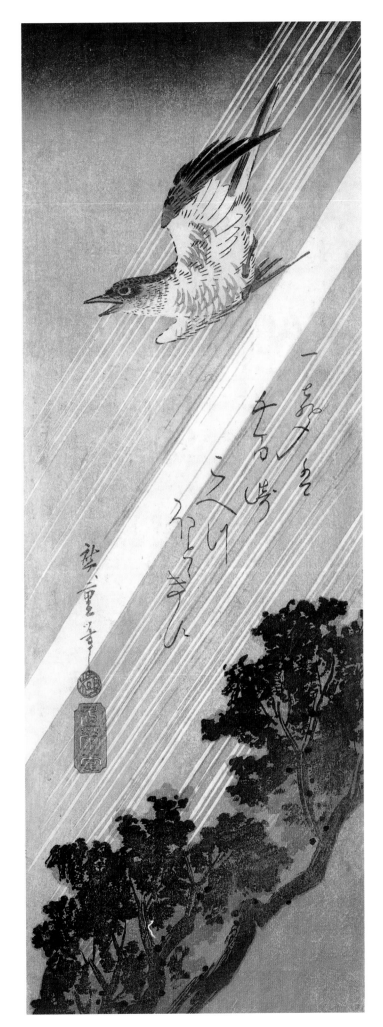

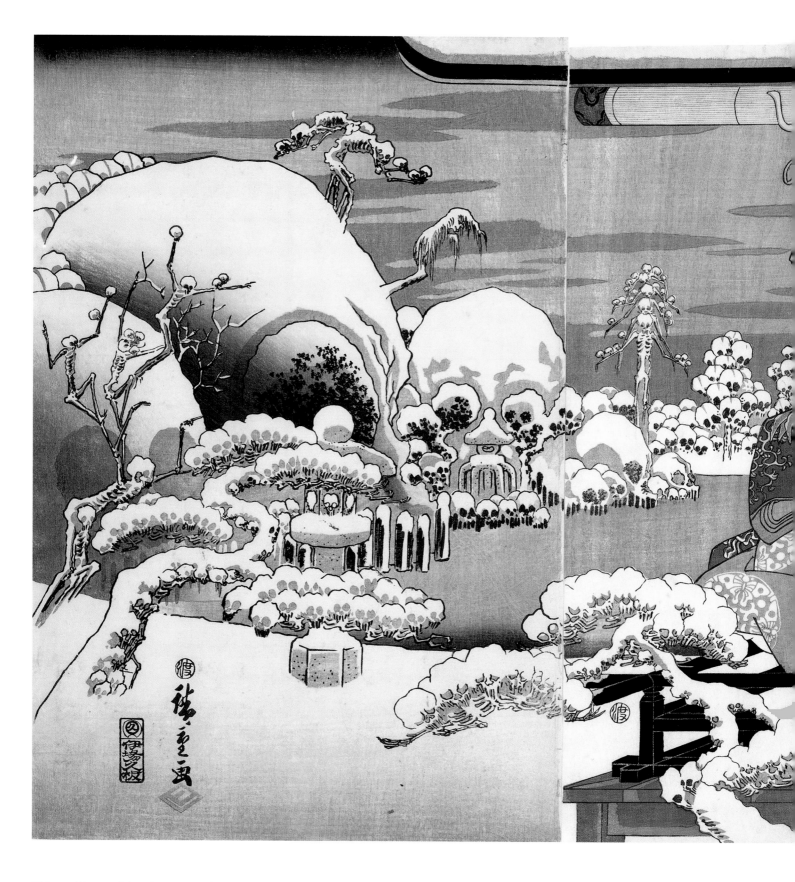

Taira no Kiyomori Sees Supernatural Phenomena
Published by Ibaya Kyūbei, mid 1840s
Colour print, ōban, triptych, 35.2 x 75 cm
(13.9 x 29.5 in.)

Taira no Kiyomori, who was notorious for his brutality and cruelty in the war against the Minamoto clan in the 12th century, is said, towards the end of his life, to have been pursued by

hallucinations. Hiroshige depicts the historical anti-hero in a garden of boundless horror: against an icy overcast sky, around a grey-blue lake countless death's heads gather; under the thick blanket of snow they are recognizable as such only on closer inspection. Fear and depression hold a soul captive and cannot be banished from the luxuriously appointed but ghostly villa. After the famines between 1832 and 1838, which led to rioting nationwide, Edo was devastated by

a catastrophic fire in 1841, which in turn was followed by severe earthquakes. Many saw these events as bad omens. The shogunate sought to take control of the situation by among other things drastically tightening the censorship laws. Publishers were told to give more attention to the ancient heroic epics and to thematize uplifting material in order to counter the decline in morals and propagate Confucian virtues. By depicting Taira no Kiyomori, Hiroshige was

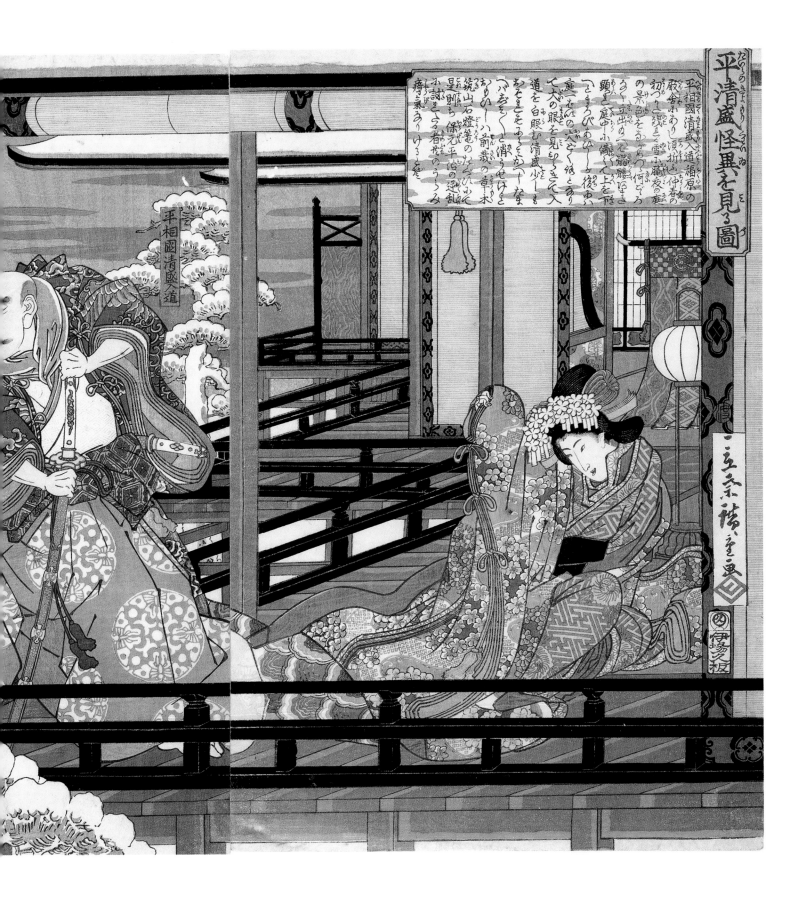

平相國清盛入道

平清盛怪異を見る圖

一立斎廣重画

歌川板

without a doubt complying with the require-
ments of the censorship authorities. But we may
assume that he was also alluding to the military
rulers of his own day, for example by adjusting
fashions and architecture to those of the Edo
period.

A Ship Approaching Land and a Tea Bowl on a Saucer
From the series "Improvised Shadow Pictures" (*Sokkyō kageboshi zukushi*), published by Tsutaya Kichizō, early 1840s
Colour print, ōban, 37.5 x 25.9 cm (14.8 x 10.2 in.), two prints not cut apart

The sheet bears the signature "Hiroshige with playful brush", which points to the humorous character of his series "Improvised Shadow Pictures". A man with a broom and shells (?) on the backs of his hands has sat down in a daring pose on a stool: his shadow on the paper panel of a sliding door has the appearance of a junk with two oarsmen. In the scene below, a basket on his head gives him the silhouette of a bowl on an oversized saucer.

aspects of a place, its local specialities, and culinary or craft products in a single sheet. This demanded particular graphic skill, but often allowed the reworking of ideas already used or the development of new ones. This print is a very good example of the versatility of Hiroshige's stylistic repertoire. In the black-and-white field on the right with its decoratively staged bridge balustrade he has recourse to the style of Chinese stone-rubbings, and the nocturnal rear view of the geisha with a lantern comes across as a "forerunner" of the geisha in the nocturnal view of Matsuchiyama (p. 71). With the demand for prints being so great, an ability to reuse motifs in this way was very important.

In summary, one may conclude that Hiroshige's work in the 1830s was characterized by great originality. Inspired by European models and also by the Kyoto-

Two Blind Masseurs Eating Kuzu Soup; The Fox as Buddhist Preacher
Published by Moritaya Hanzō, 1840–1842
Colour print, ōban, 37.3 x 26 cm (14.7 x 10.2 in.),
two prints not cut apart

Hiroshige's caricatures bear witness to his unmistakable satirical humour and make him an important forerunner of the modern Japanese comic-strip *(manga)*. Here, two blind masseurs have sat down at a street snack-bar to enjoy *kuzu* soup. When they get up, one of them catches his garment on the corner of the table, and, unbeknown to him, his backside is exposed. The charcoal brazier on the upturned table has singed the beard of the other blind man. In the scene below, a laughing paunchy Buddha is amused when a hypocritical fox pretends to be a Buddhist preacher. His audience consists of a credulous bloated toad and a stupid-looking fish dressed in his best clothes. They are listening intently, and have piled up a substantial quantity of money in front of the fox.

PAGE 76:
A Boy Paints the Eyebrows of a Dreaming Bookkeeper; Schoolboys Scare their Teacher
Published by Moritaya Hanzō, 1840s
Colour print, ōban, 37 x 25 cm (14.6 x 9.8 in.),
two prints not cut apart

A bookkeeper has dosed off over the book on his cabinet. From his heart rises the huge bubble which reveals his dream, his secret desires: not only a little table with bowls and boxes of select food and drink, but also the corner of a futon peeking out from behind a screen, betray that he is dreaming of a night in the pleasure district. Grinning, the apprentice paints his eyebrows. In the scene below, pupils scare their teacher, evidently a brave samurai, who carries his short sword in his girdle, but loses his nerve when he sees a ghost.

based Maruyama-Shijō school, he created atmospheric verist landscapes and depicted aspects of human life which had not previously been regarded as picture-worthy. His view of humanity is sober and in no way idealistic, but is nonetheless distinguished by an inimitable humour, sympathy and great human sensitivity. In the early 1840s, we begin to see signs of fatigue. His monumental late work, from about 1848 to his death, is in turn characterized by great painterly confidence and boldness, but also by greater abstraction and detachment and less emphasis on the narrative element. Not only in his "36 Views of Mount Fuji" in horizontal format (p. 80) dating from 1852, but also in those in vertical format that he made in the last year of his life, for example the view of the plain of Ōtsukigahara (p. 2), we see more strongly the influences of the decorative two-dimensional painting of the Kyoto-based Rinpa school, which was repre-

***The War Between the Mochi Rice-Cake and the
Sake Rice-Wine***
Published by Maruya Seijirō, mid 1840s
Colour print, ōban, triptych, 36.5 x 76.3 cm
(14.4 x 30 in.)

All kinds of *sake* containers, bottles and cala-
bashes have gathered together to form a horde
of wild samurai. They have declared war on
rice-cakes of whatever shape or taste.

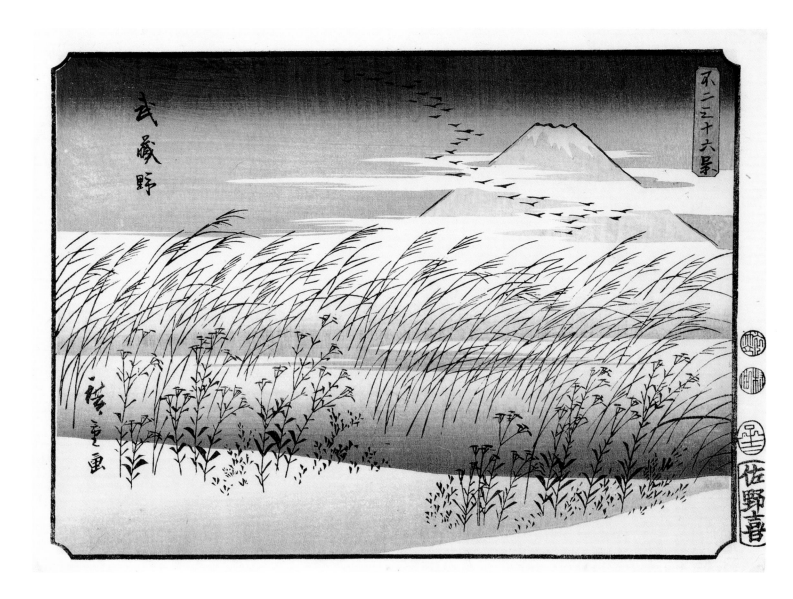

Musashino Plain
From the series "36 Views of Mount Fuji" (*Fuji sanjūrokkei*), published by Sanoya Kihei, 1852
Colour print, chūban, 16.4 x 22.9 cm (6.5 x 9 in.), border preserved

In its reductionist simplicity, Musashino Plain with Mount Fuji in the background is typical of Hiroshige's late work. Grasses and groups of flowers are positioned like a delicate breath in front of the flat landscape composition.

sented in 19th-century Edo by Sakai Hōitsu (1761–1828) and his pupil Kiitsu (1796–1858). More or less two-dimensionally depicted grasses and flowers in opulent colours are grouped in the manner of Hōitsu against the backcloth of Mount Fuji, while a sense of spatial depth is created by the zigzag ribbon of the river. His view of people also becomes more detached and takes on a cool acuity. In the sheet with rain in the Yamabushi Gorge (p. 81) for example from the series "Famous Views of 60-Odd Provinces" (*Rokujū yoshū meisho zue*) which appeared between 1853 and 1855, the rain whipping diagonally across the picture, through which the mountain ascetics (*yamabushi*) can be seen struggling with the storm in the middle distance, has an altogether decorative quality, when compared for example with the depictions of rain in the 1830s, such as *Night Rain in Karasaki* (p. 43).

Deep seriousness and palpable serenity, as though Hiroshige felt his end approaching, are radiated by the monumental triptych of the snowscape in the Kiso mountains (pp. 82–83) dating from 1857, which takes up compositional techniques from Chinese painting. We view a gorge in the Kiso mountains from a bird's-eye perspective. Our gaze wanders through snow-covered valleys and thinly wooded heights, over bridges with tiny figures which seem embedded in the cosmos of an overmighty, all-embracing nature. One is tempted to say it is a question of temperament and personality whether one finds more admiration for the inventiveness and the delight in experimentation of Hiroshige's works

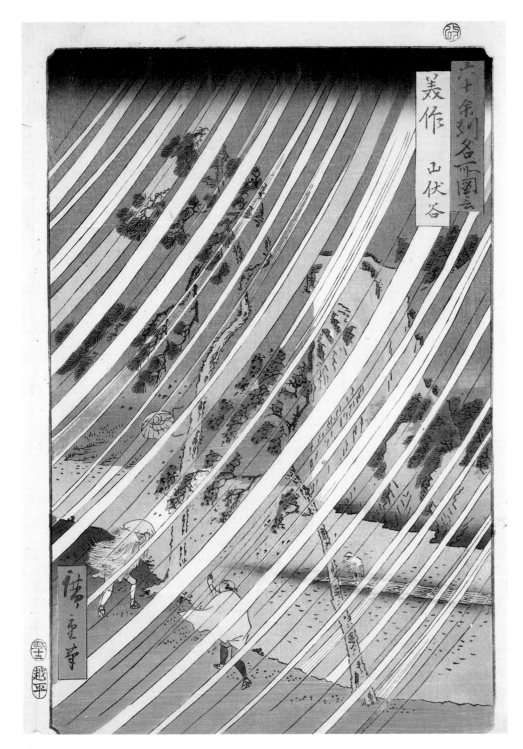

The Yamabushi Gorge in the Province of Mimasaka
From the series "Famous Views of 60-Odd Provinces" (*Rokujū yoshū meisho zue*), published by Koshimuraya Heisuke, 1853
Colour print, ōban, 34.5 x 23 cm (13.6 x 9 in.), border preserved

In Hiroshige's late work his view of people also became more detached. The rain, lashing down diagonally across the picture, lies like a decorative foil across a landscape in which two mountain ascetics and a boatman are fighting against the storm.

of the 1830s, or for his mature late work, distinguished as they are by daring, original compositions and techniques but also by greater stylization and emotional detachment.

PAGES 82–83:
Mountain and River on the Kisokaidō
From an untitled series of triptychs, published by Okazawaya, 1857
Colour print, ōban, triptych, 37.1 x 76.5 cm (14.6 x 30.1 in.)

This monumental triptych of a snowscape in the Kiso mountains, completed shortly before Hiroshige's death, radiates deep seriousness and great serenity. Our gaze wanders through snow-covered valleys and over sparsely wooded heights, over bridges with tiny figures embedded in the landscape as part of a natural all-encompassing cosmic order.

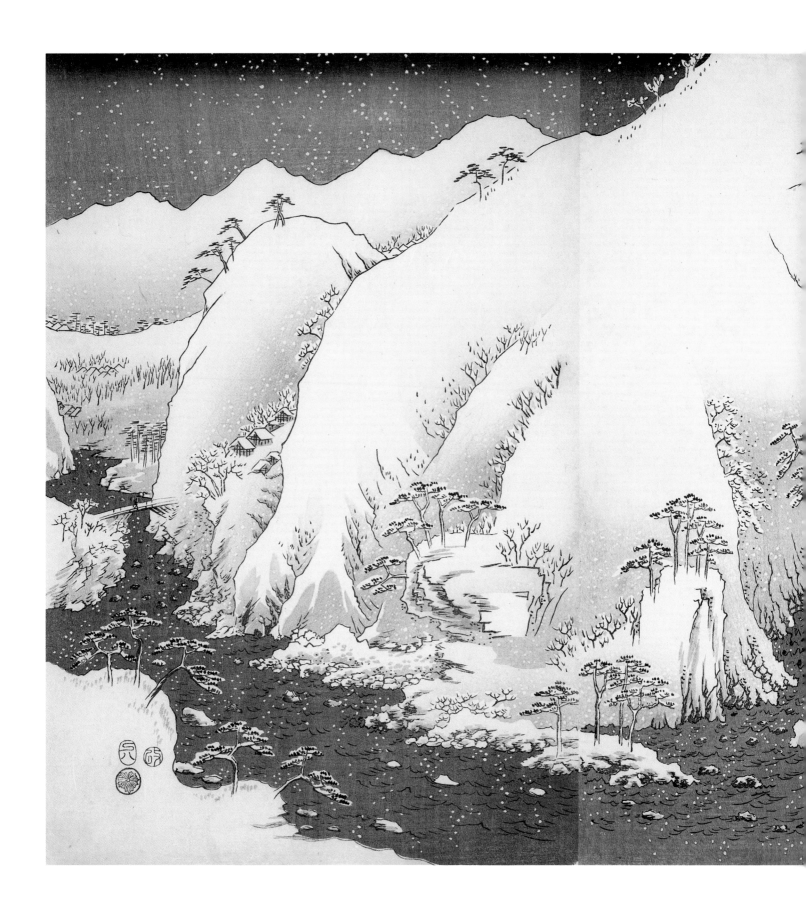

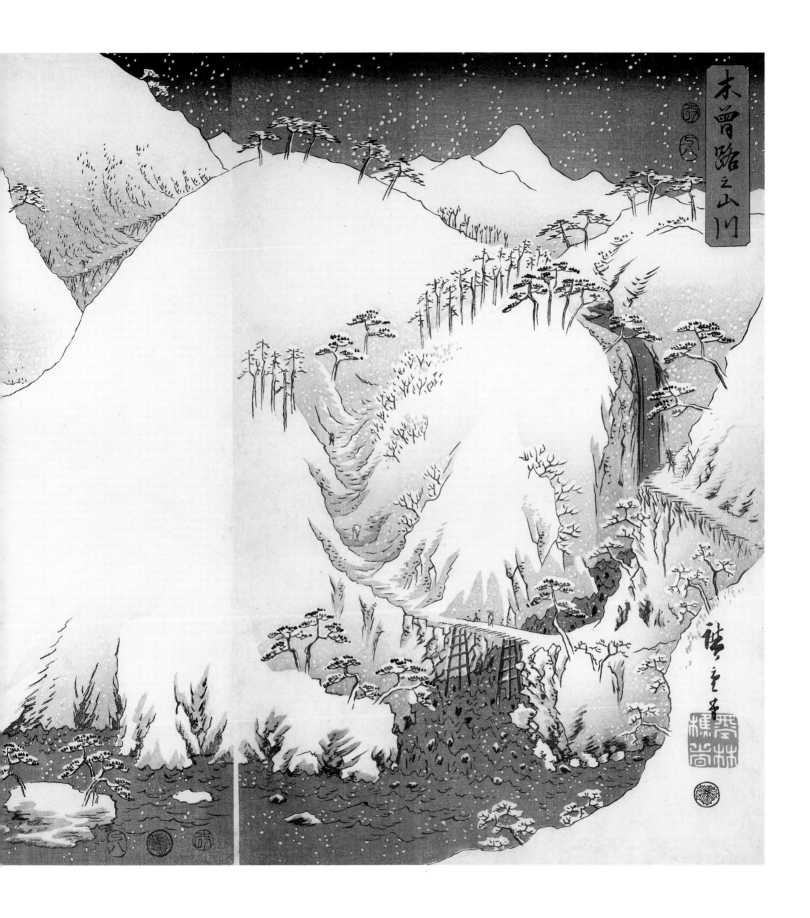

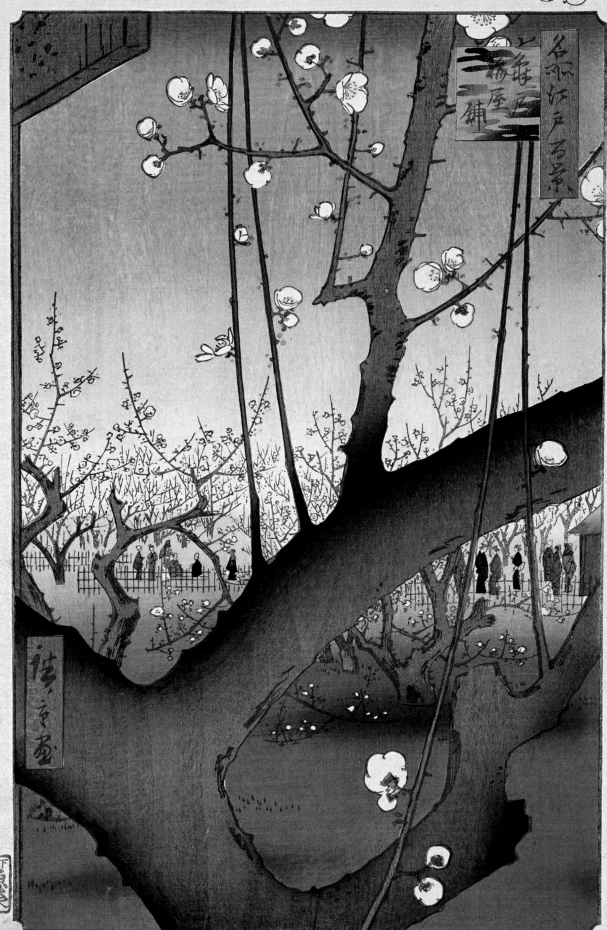

Hiroshige and European Japonism

The woodblock art of pre-modern Japan – and above all Hiroshige's landscape prints – revolutionized European painting and made a major contribution in the last two decades of the 19th century to the development of Impressionism. How can we explain this phenomenon, and what logic was followed by this process of appropriation? The opening-up of Japan and the world exhibitions in London (1862) and Paris (1867) introduced Japanese woodblock prints to Europe for the first time in any number. And it was above all the landscape prints by Hiroshige that exerted a special fascination on the artists of the day. With their unusual composition techniques, but also with their moody, often lyrical coloration, which served the depiction of momentary atmospheric light and weather conditions, they provided an appropriate instrument by which the academic tradition of central perspective and three-dimensional representation of bodies, but above all the concept of a hierarchically structured, stable pictorial space could be overcome.

Receptivity for the Japanese colour print was not something that could be taken for granted and had no tradition in Europe. In the 17th and 18th centuries, the *horror vacui* still dominated European taste, which, convinced of its own superiority, often disparaged Chinese and Japanese landscape compositions, for example on Far Eastern lacquerwork, as unfinished or even as amateurish, while the exotic products of Chinese and Japanese porcelain and lacquer factories were raised to the status of a new, albeit European-style, "total work of art" when piled up to the ceilings in the cabinets of curiosities maintained by the princely courts. The enthusiasm for Japanese coloured woodblock prints was due by contrast to the need for new pictorial techniques and contents, with which artists sought to give expression to the dramatic changes that were occurring in Europe in the 19th century. Phenomena such as industrialization and the beginnings of a mass culture, the rapid acceleration of time brought about by new means of transport and mechanical technologies, the anonymity of the individual in the city, the dissolution of traditional hierarchies and a new sensitivity for the transience of the moment, but at the same time the cosmopolitanism and pioneering spirit of a prospering middle-class, called out for the development of a new, dynamic pictorial language. Europe was in a phase of upheaval, which had at least distant parallels with the development of urban culture in the Edo period and the manifestations of decay which marked

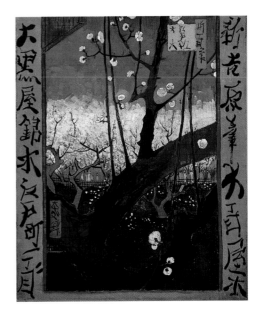

Vincent van Gogh
Japonaiserie: Blossoming Plum Tree
(after Hiroshige)
Paris, September–October 1887
Oil on canvas, 55 x 46 cm (21.7 x 18.1 in.)
F 371, JH 1296
Amsterdam, Van Gogh Museum,
Vincent Van Gogh Foundation

In his copy of the *Plum Orchard in Kameido*, van Gogh keeps quite closely to Hiroshige's composition, but deviates in particular in the coloration of the sky. In this way he achieves a strongly subjective and emotional expression.

Plum Orchard in Kameido
From the series "100 Famous Views von Edo"
(*Meisho Edo hyakkei*), published by Uoya
Eikichi, 1857
Colour print, ōban, 36.3 x 24.6 cm (14.3 x 9.7 in.)

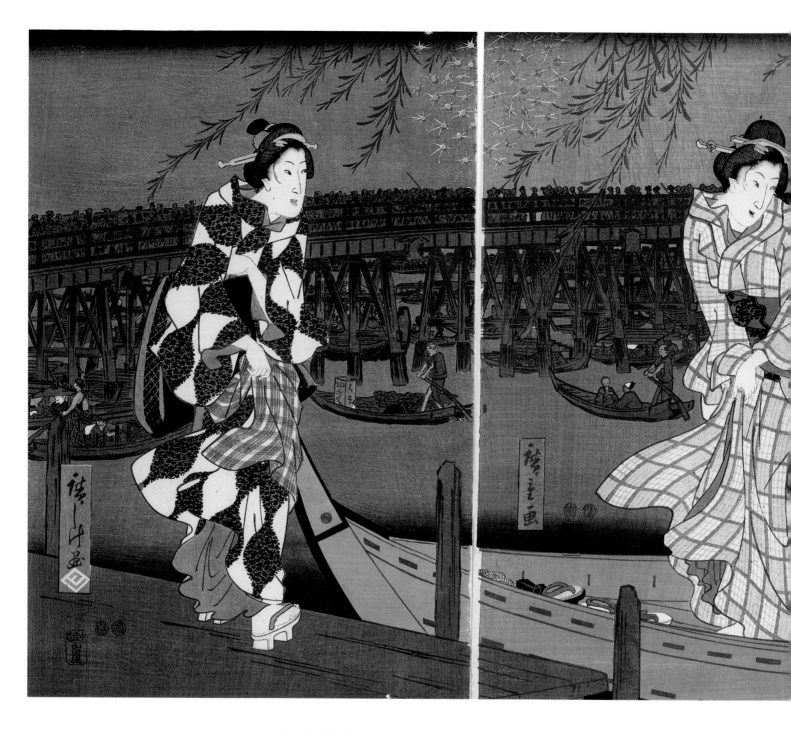

James Abbott McNeill Whistler
Caprice in Purple and Gold No. 2: The Golden Screen, 1864
Oil on panel, 49.8 x 68.9 cm (19.6 x 27.1 in.)
Washington (DC), Smithsonian Institution, Freer
Gallery of Art, Gift of Charles Lang Freer, F1904.75.

the feudal shogunate regime in 19th-century Japan. To this extent it is doubtless no coincidence that European artists found in Hiroshige precisely what he had sought, among other things, in his own confrontation with European modes of depiction: a new view of the world and new methods of interpreting reality.

In 1872 Philippe Burty (1830–1890), an enthusiastic collector of Japanese woodblock prints, published a series of articles in the magazine *La Renaissance littéraire et artistique* under the title "Japonisme". It took a critical look at the new Japan movement in art, and at the same time coined the term Japonism (or "Japonisme", the French word also being used in English), which is still current today. In 1875 the essay was printed in an English translation in the magazine *The Academy* in London, which was developing alongside Paris into the centre for "the study of the art and genius of Japan". In his 1878 book *Le Japon à Paris*, Ernest Chesneau remarks on the enthusiasm unleashed in the graphic artist Félix Bracquemond (1833–1914) and the painters Alfred Stevens (1823–1906) and

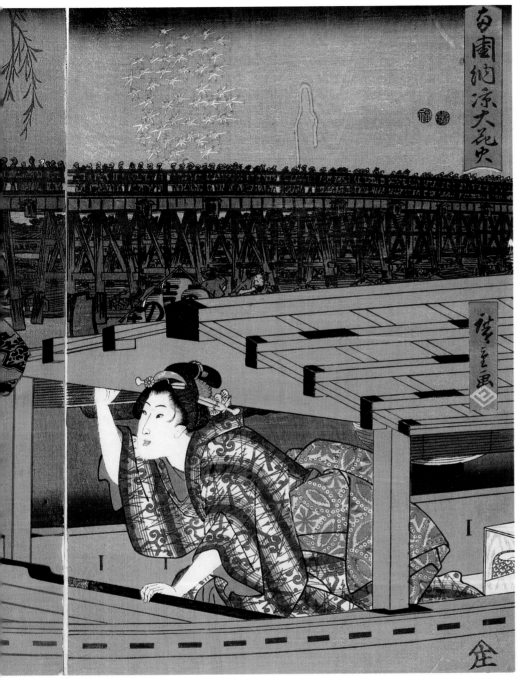

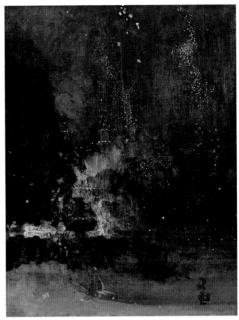

James Abbott McNeill Whistler
Nocturne in Black and Gold: The Falling Rocket, 1875
Oil on panel, 60.2 x 46.7 cm (23.7 x 18.4 in.)
Detroit (MI), The Detroit Institute of Arts,
Gift of Dexter M. Ferry, Jr.

With his *Nocturnes* Whistler unleashed outrage among certain critics, who accused him of intentionally insulting the public by "flinging a pot of paint" in their faces and giving them cropped compositions devoid of any content. The series, which largely consists of nocturnal views of the Thames, is without a doubt inspired by Hiroshige's prints (pp. 25 top, 86–87), and this is particularly true of the painting presented here with the depiction of a firework display.

James McNeill Whistler (1834–1903) by a sketchbook by Hokusai discovered by an artist in a chest of Oriental goods at a Parisian art-dealer's shop. The Impressionists were soon to follow.

The American-born James McNeill Whistler was a friend of Bracquemond's and had lived since 1855 in Paris, before moving in 1863 to London, where he played a decisive role in spreading Japonism in England. In 1864 Whistler painted his girlfriend Joanna Hiffernan (in a kimono) looking at woodcuts by Hiroshige, with a Japanese screen in the background (p. 86 bottom). Not only the depicted props, but also the composition with its bird's-eye perspective and the various motifs projecting into the picture, leave no doubt as to Whistler's affinity to Japonism. Even more striking is the influence of Hiroshige on Whistler in the 1870s. Under the title *Nocturnes*, he painted a series of 30 riverscapes of the Thames, mostly by night, including the depiction of a firework display (p. 87 right). Whistler also knew how to get collectors such as Charles Lang Freer (1854–1919) interested in Japanese art. In 1894, the latter went on a world

Great Firework Display near Ryōgoku Bridge
Published by Yamadaya Shōjirō, c. 1850
Colour print, ōban, triptych, 38.1 x 77.1 cm
(15 x 30.4 in.)

In the hot summer months people would take boat-trips along the Sumida River to keep cool. On the 28th day of the 5th month, the season was inaugurated by a purification ritual known as a *kawabiraki* (opening of the river), which was accompanied by an imposing firework display. Pleasure-boats were available for hire, on which geishas or girl musicians provided the entertainment and offered the guests food and drink.

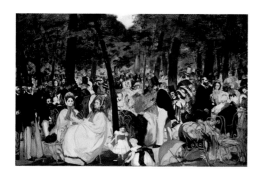

Édouard Manet
Music in the Tuileries Garden, 1862
Oil on canvas, 76 x 118 cm (29.9 x 46.5 in.)
London, National Gallery

In the painting *Music in the Tuileries Garden*
the casually arranged trees form a grid in which
can be seen an amorphous crowd of obviously
affluent but for the most part faceless, de-indi-
vidualized citizens.

Édouard Manet
Portrait of Émile Zola, 1868
Oil on canvas, 146 x 114 cm (57.5 x 44.9 in.)
Paris, Musée d'Orsay

His flat style of painting earned Manet a deal
of criticism, but he was defended by his friend
Émile Zola in an 1866 article which praised his
"Japonism". In Manet's portrait of Zola this art-
icle is lying on the desk, while on the wall in the
background hangs a Japanese woodblock print
and on the left a gilt screen projects into the pic-
ture. These props also show Manet to have been
an enthusiastic collector of Japanese art.

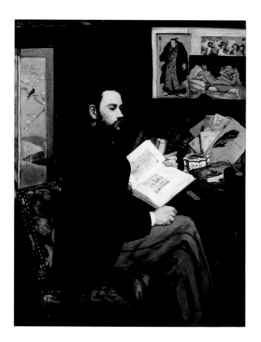

tour which took him among other places to Japan, where he compiled an out-
standing collection of Japanese art. In 1904, after acquiring Whistler's famous
Peacock Room, he offered his collection as a gift to the American people, repres-
ented in this case by the Smithsonian Institution, Washington, DC, and also
provided the funds to build a home for it, namely the Freer Gallery of Art, com-
pleted in 1923.

Japanese-inspired painting was by no means universally popular, as not only
Whistler, but also Édouard Manet (1832–1883) found out to his cost. His friend
Émile Zola (1840–1902) defended him in an article published in 1866, and fêted
his Japonism in particular. Manet's portrait of Zola (p. 88 bottom) not only
shows this essay lying on the desk, but also a Japanese woodcut on the wall,
while to the left, behind the writer, a Japanese screen projects into the picture.
In Manet's composition *Music in the Tuileries Garden* (p. 88 top) the casually
arranged trees form a grid in which the viewer sees an amorphous crowd of
evidently well-heeled, but largely faceless citizens. This is a compositional
scheme whose inspirational sources may well have included Hiroshige's plum
orchard in Kameido (p. 84).

Edgar Degas (1834–1917) was a member of the society of etchers founded
by Bracquemond, and a friend of both Manet and Whistler. He too possessed
numerous coloured Japanese woodcuts, and felt particularly attracted to the
world of transient pleasures. Opera and ballet, front-of-house and backstage
scenes were his subject. In the works of Degas, it is particularly the cropped
pictorial space, the asymmetric composition and the shimmering blur of the
colours that capture the mood of the moment and point to Hiroshige's in-
fluence.

Claude Monet (1840–1926), another enthusiastic collector of Japanese wood-
cuts, is said to have covered the walls of his house in Giverny with more than
200 of them. He transformed his garden into a Japanese landscape. He created
ponds with water-lilies and, influenced by a Hiroshige woodcut, was inspired to
build an arched bridge in the Japanese style. In one of the famous views of his
garden (p. 91 top), plants and water form a dense colour-carpet; it is only the
shrubs on the left and the bridge, which he places across the picture without a
visible beginning or end, that give any hint of spatial depth, a device which we
have seen in Hiroshige too, for example in his late version of the Sanjō-Ōhashi
Bridge in Kyoto (p. 56). Evidently Hiroshige's famous series of landscapes inspi-
red not only Whistler, but Monet too, to paint series or cycles of particular land-
scapes. In his series of the Seine and the cathedral in Rouen, or his large-format
water-lily series, he represents the subject in different lights and in an atmo-
spheric mood that is different each time. In Hiroshige, Monet clearly found an
artist of the transient and ever-changing.

Alongside the artists, art critics and writers, for example Jules and Edmond
de Goncourt, it was however first and foremost the dealers who were mainly
responsible for the widespread acceptance of all things Japanese. Samuel (Sieg-
fried) Bing opened a shop for Far Eastern art in Paris, and one of the artists
who regularly studied his prints and pictures was Vincent van Gogh. In one of
his letters to his bother Theo, he speaks of millions of prints that he studied in
Bing's attic, some of which, it goes without saying, he bought. In 1888 Bing
began publishing a monthly in French, English and German under the title
Artistic Japan. The title pages showed coloured reproductions mostly of wood-
block prints. The number illustrated here (p. 91 bottom) is not difficult to
identify as the reproduction of a mandarin duck by Hiroshige. Bing's magazine

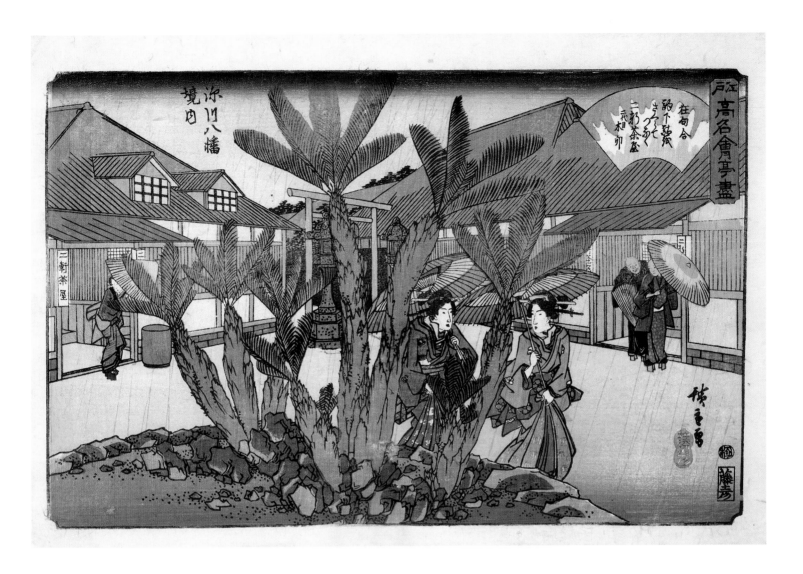

was also a source of inspiration to Henri de Toulouse-Lautrec, Gustav Klimt and Paul Gauguin.

In 1887 the van Gogh brothers exhibited their collection of Japanese woodblock prints at the Café Tambourin in Montmartre, and the same year Vincent copied Hiroshige's famous Ōhashi Bridge and Kameido Orchard from the series "100 Famous Views of Edo" (pp. 84, 85). The plum orchard in Kameido was famous for an ancient scented plum tree. Some branches of this tree had layered new roots, which in turn grew new branches. Its unbroken lusty vitality gave it the name "Plum of the Sleeping Dragon". Hiroshige has placed the curious grid of its branches in the foreground of the composition. Behind, we see more plum trees in full bloom, and city dwellers strolling in the evening sunshine. Van Gogh added Japanese calligraphy to the borders to acknowledge his inspiration.

Compared with Hiroshige's view of the Kameido Garden, in van Gogh's picture a glowing red evening sky stands out behind a shimmering yellow ribbon that suggests the overwhelming splendour of the plum blossom. While van Gogh remained faithful to the original in all the other details, the crimson sky represents a radical change: instead of Hiroshige's characteristic subdued tones with their gentle, transparent colour transitions from red to pink achieved with the *bokashi* technique, van Gogh confronts the beholder with a dramatically exaggerated colour contrast, which gives his picture a deliberately intense, far more emotional aura. Van Gogh even copied the cartouches with the series title

The Nikenjaya Tea-house by the Hachiman Shrine in Fukagawa
From the series "First-class Restaurants and Tea-houses in Edo" (*Edo kōmei kaitei zukushi*), published by Fujiokaya Hikotarō, 1835–1842
Colour print, ōban, 22.1 x 35 cm (8.7 x 13.8 in.), border preserved

The urban bourgeoisie developed a taste for good food and select regional or seasonal specialities and were well informed about the classiest restaurants and tea-houses.

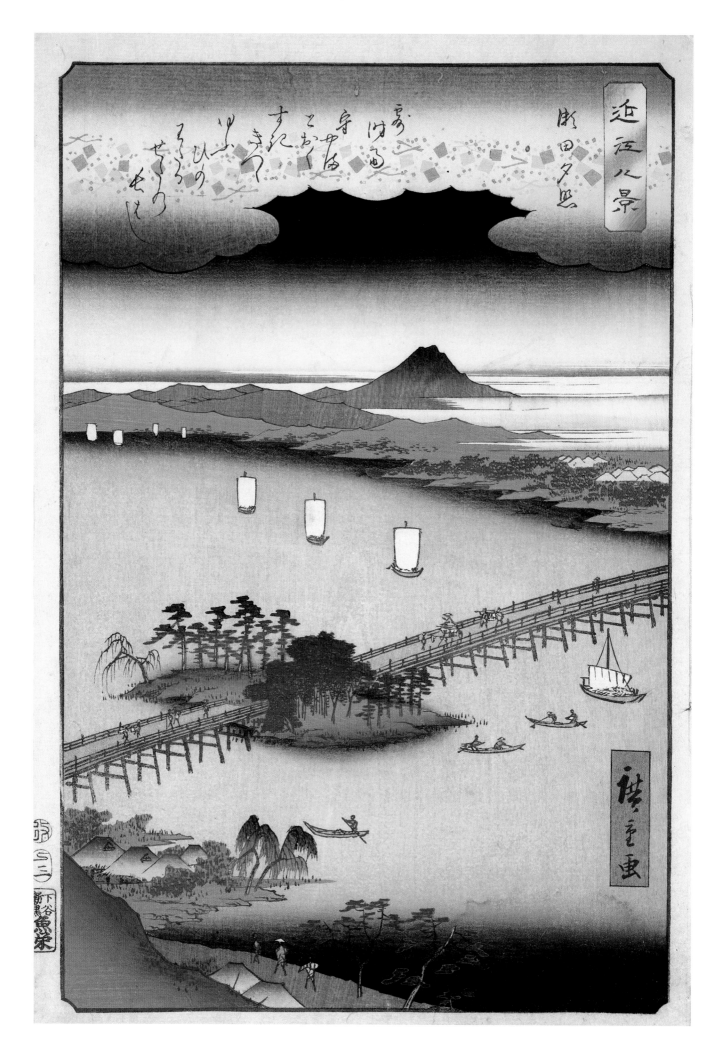

90

and the description of the view, although the characters are difficult to decipher and removed from their context. The columns of characters to the side are an invention of van Gogh's: he simply imitated any old characters from other woodblock prints, and together they make no sense. The series starts in the top right with Shin Yoshiwara (New Yoshiwara quarter) *hitsu* (painted) *dai chōme*, and at the bottom we have Daikokuya (publisher's name), *nishiki* (polychrome print), *Edochō ichōme*. The lateral character columns are integrated into the picture as a decorative exotic framework.

In a 1901 essay, Mary McNeill Fenollosa, the wife of the famous art-historian Ernest Fenollosa (1853–1908), who put modern Japanese art history on a Western scholarly footing, called Hiroshige "the artist of mist, snow and rain". And indeed, Hiroshige's great importance for European art lies in the fact that he provided a new artistic language by which the subjective perception not only of light and atmospheric mood but also of movement could be expressed and interpreted in a hitherto unknown way. Thus Hiroshige is among the few Far Eastern artists who have been admitted to the Western art-historical canon, and whose pioneering genius in the story of world art points far beyond the limits of his own time and place.

Claude Monet
The Japanese Bridge, 1900
Oil on canvas, 89.2 x 92.8 cm (35.1 x 36.5 in.)
W.IV. 1630
Boston, Museum of Fine Arts, gift in memory of Governor Alvan T. Fuller of the Fuller Foundation, 1961
Reproduced by kind permission of the museum

PAGE 90:
Seta Bridge in Evening Light
From the series "Eight Views of Ōmi Province" (*Ōmi hakkei no uchi*), published by Uoya Eikichi, 1857
Colour print, ōban, 34 x 22.5 cm (13.4 x 8.9 in.), border preserved

Japanischer Formenschatz
Monthly journal, published by S. Bing, title page of no. 1
Leipzig: Seemann, 6 vols., 1888–1891
Berlin, bpk / Kunstbibliothek, Staatliche Museen zu Berlin (Lipp Lf 45)

Hiroshige 1797–1858
Chronology

1797 Hiroshige is born, the eldest son of a samurai family named Andō, and receives the given name Tokutarō. His father Andō Genuemon held the hereditary post of *hikeshi dōshin*, a member of the Edo fire brigade. As a minor official of the shogunate regime, he received a modest salary to oversee the fire station in the Yayosugashi quarter in the heart of Edo (present-day Tokyo). In his youth Hiroshige was also called Tokutarō, Tokubei and Jûemon, among other names.

1806 Hiroshige is introduced to the Chinese-influenced painting style of the Kanō school by amateur painter Okajima Rinsai, who likewise held a position with the fire brigade.

1809 Hiroshige's mother dies. His father, Genuemon, makes his office over to Hiroshige and dies himself at the end of the same year. At the age of 12, Hiroshige becomes head of the Andō family.

1811 Hiroshige becomes a pupil of the ukiyo-e painter Utagawa Toyohiro (1774–1829).

1812 Hiroshige is given permission by his teacher to use the name of the Utagawa school and signs his early works "Hiroshige", the character for *hiro* being borrowed from the name of his teacher Toyohiro and combined with a different reading for the character *jū* of his given name.

1818 Hiroshige draws illustrations for a volume of comic poems (*kyōkabon*). He composes prints of actors in the style of Utagawa Kunisada (1786–1865).

1820s Composition of various series of prints featuring beautiful women (p. 46).

LEFT:
Gorge in Snow
Untitled private edition, published by Sanoya Kihei, 1843/44
Colour print, double ōban, 73.6 x 25.1 cm (29 x 9.9 in.)

RIGHT:
Waning Moon
From the series "28 Views of the Moon" (*Tsuki nijū hakkei no uchi*), published by Jakurindō (Wakasaya Yoichi), c. 1832
Colour print, ōtanzaku, 38.1 x 17.5 cm (15 x 6.9 in.)

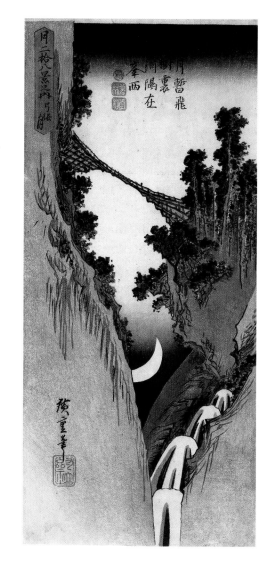

1821 Hiroshige marries the daughter of the fireman Okabe Yuaemon.

1823 Hiroshige officially bequeaths his position at the fire brigade to his son Nakajirō. As the latter is too young to exercise the duties of the office, it is not until 1832 that Hiroshige is finally able to devote himself entirely to painting.

1828 His teacher Utagawa Toyohiro dies, and Hiroshige assumes the artist name Ichiyûsai.

1831 Hiroshige changes his signature by using a different character for the component *yū* in Ichiyûsai. He uses this signature for his ten-part series "Famous Views of the Eastern Capital" (*Tōto meisho jukkei*).

1832 In the 3rd month Hiroshige withdraws completely from his position in the fire brigade. In the summer he is said to have accompanied an official delegation of the shogunate government to Kyoto, whose purpose was the annual ceremonial handover of tribute horse by the shogun to the emperor on the 1st day of the 8th month. With the impressions of the trip still very much in his mind, he is said, following his return to Edo, to have devoted himself during that very same autumn to the "53 Stations of the Tokaidō" (*Tōkaidō gojūsantsugi*). The series is printed between 1832 and 1834 by Takenouchi Magohachi, who runs the Hōeidō publishing house. This Hōeidō edition (*Hōeidō tōkaidō*), as it is known, helps Hiroshige to make his artistic breakthrough (pp. 8, 10–11, 54, 55, 56, 57, 95).
Hiroshige changes his artist name from Ichiyûsai to Ichiryûsai. The publisher Sanoya Kihei starts to issue his "Famous Views of the Eastern Capital" (*Tōto meisho*; pp. 24, 30–31, 33, 37, 67). In addition, there appear prints of birds and flowers (*kachōga*; pp. 1, 72, 73).

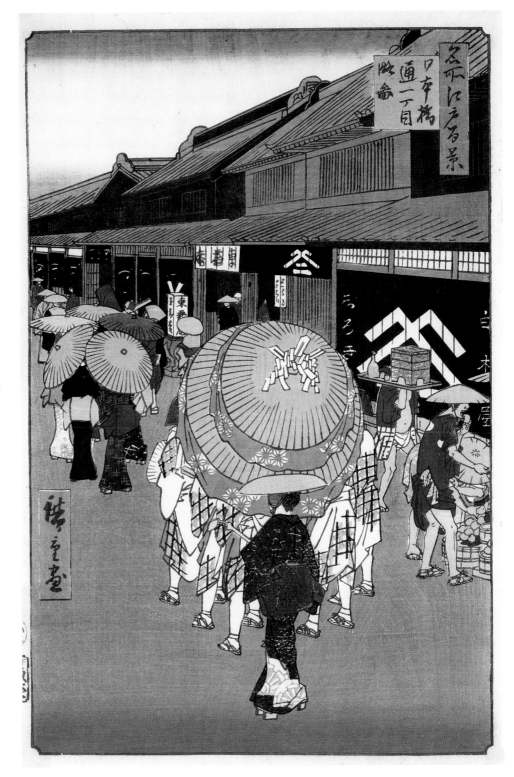

1832/33 The series of large fish appears (p. 39).

1832–1837 The series "Famous Views of Our Country" (*Honcho meisho*) appears.

1832–c. 1838 A disastrous harvest leads to a famine that hits ordinary people hard and leads to riots. The shogunate tries to combat the serious political

View of Nihonbashi Street
From the series "100 Famous Views of Edo" (*Meisho Edo hyakkei*), published by Uoya Eikichi, 8th month of 1858
Colour print, ōban, 33.9 x 22.4 cm (13.3 x 8.8 in.), border preserved

Groups of people are moving along Nihonbashi Street in the cotton-merchants' quarter. A street salesman on the right is offering melons as refreshment, while behind him an airily dressed messenger is carrying a tray piled with boxes for cold noodles, a speciality of the restaurant in the middle of the row of buildings.

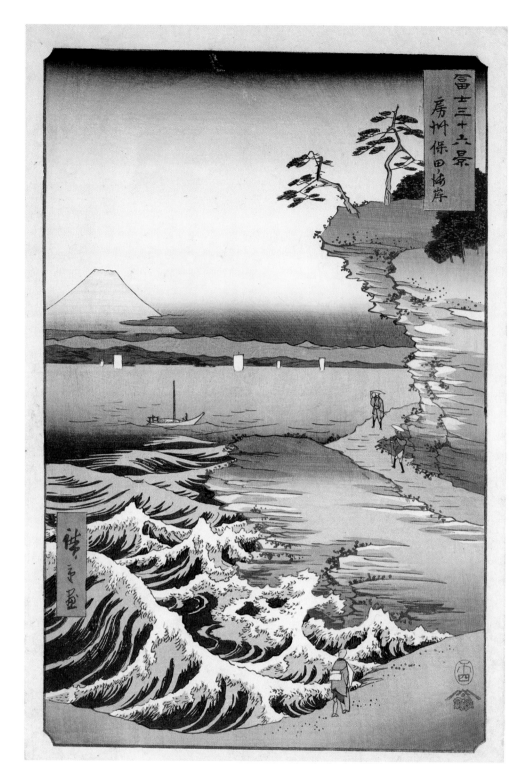

The Hoda Coast in Awa Province
From the series "36 Views of Mount Fuji" (*Fuji sanjūrokkei*), published by Tsutaya Kichizō, 1858
Colour print, ōban, 33.8 x 22.4 cm (13.3 x 8.8 in.), border preserved

This view of the Hoda coast with Mount Fuji in the background was executed by Hiroshige shortly before his death, and is typical of his late work. Special note should be taken of the subtle colour shading to modulate the cliffs and the shore, and also of the surf and the deep-purple fog banks on the horizon.

in the 1830s by Keisai Eisen (1790–1848) and now completed by Hiroshige. In the same period appears the series "First-class Restaurants and Tea-houses in Edo" (*Edo kōmei kaitei zukushi*; p. 89).

1839 Hiroshige's wife dies. The printing of the Kisokaidō series is interrupted.

1839/40 The series "53 Stations of the Tokaidō with Kyōka (comic) Poems" (*Kyōka tōkaidō*) appears.

1840s Hiroshige composes the "Improvized Shadow Pictures" (*Sokkyō kageboshi zukushi*; p. 76 top), caricatures (*giga*; pp. 76, 77) and comic prints (pp. 78–79).

1841/42 Publication of the what is known as the Gyōsho edition of the "53 Stations of the Tokaidō" (*Gyōsho tōkaidō*; p. 58).

crisis by stricter controls on all areas of life.

1834 The complete series of "53 Stations of the Tokaidō" appears in two albums with an advance notice of further series.

1834/35 The series "Eight Views of Ōmi Province" (*Ōmi hakkei*; p. 43) appears. Other works that appear at this time include the series "Famous

Views of Kyōto" (*Kyōto meisho*; p. 9) and the series "Famous Views of Ōsaka" (*Ōsaka meisho*; p. 36) as well as the series "Six Tama Rivers of Various Provinces" (*Shokoku mutamagawa*; p. 66). Beginning in this year, Hiroshige draws illustrations for numerous albums of comic verse.

1835–1842 The series "69 Stations of the Kisokaidō" (*Kisokaidō rokujūkyūtsugi no uchi*; pp. 64, 65) appears, begun

1842/43 The reforms of the Tenpō era lead to numerous restrictions in publishing; for example prints of actors and courtesans are banned, as are luxury editions. What is encouraged are prints on the theme of historic heroes with the intention of promoting the ideals of loyalty, honour and virtue.

1844–1857 Hiroshige composes numerous series on historical and mytho-

logical themes, including some series of fan designs (pp. 50, 51, 74–75).

1847 Hiroshige marries Yasu, a farmer's daughter 15 or 16 years younger than himself.

1848–1852 Publication of what is known as the Reisho edition of the "53 Stations of the Tokaidō" (*Reisho tōkaidō*; pp. 13, 18, 42, 59, 60 bottom).

1848–1853 Hiroshige produces numerous prints of beautiful women in landscapes, above all in the form of triptychs (pp. 20–21, 38, 49, 86–87).

1849 Hiroshige moves to Kanōshindō in the Nakabashi district of Edo and borrowss 100 ryō to build a new house.

1848–1852 Publication of the series "53 Stations of the Tokaidō with Figures" (*Jinbutsu tōkaidō*; p. 63). In addition, numerous *harimaze* appear (p. 15), in which several motifs of famous places, regional products and specialties are placed together on one sheet. Hiroshige and his wife Yasu adopt a daughter, Tatsu, who later gets divorced from his favourite pupil Hiroshige II in order to marry Hiroshige III.

1853 Publication of the series "Famous Views of Edo" (*Edo meisho*; pp. 68 top, 69).

1853–1858 Publication of the series "Famous Views of 60-Odd Provinces" (*Rokujū yoshū meisho zue*; pp. 40, 81, 95).

1854 The American Commodore Matthew Perry lands with his fleet in Edo Bay and forces the opening of Japanese harbours for foreign ships.

1855 The series "Famous Views of the 53 Stations" (*Gojūsantsugi meisho zue*)

appears in vertical format (pp. 7, 12, 14, 23, 53, 60, 61, 62).

1856 Hiroshige takes the tonsure and becomes a Buddhist monk.

1856–1858 Publication of the series "100 Famous Views of Edo" (*Meisho Edo hyakkei*; pp. 6, 22, 52, 70, 71, 84, 93).

1857 Publication of three imposing landscape triptychs (pp. 82–83).

1858 Publication of the series "Mountain and Sea Compared to Wrestlers" (p. 19). After an illness lasting ten days, Hiroshige writes two wills on the 2nd and 3rd days of the 9th month respectively. He dies on the 6th day of the 9th month, probably during the course of a cholera epidemic. He is given the posthumous temple name Genkōin Tokuo Ryûsai Shinji and is buried at the cemetery of the Asakusa Tōgakuji Temple in Adachi-ku, where his grave is located to this day.

1858/59 Publication of the series "36 Views of Mount Fuji" (*Fuji san-jūrokkei*; pp. 2, 94), completed by his pupil Hiroshige II.

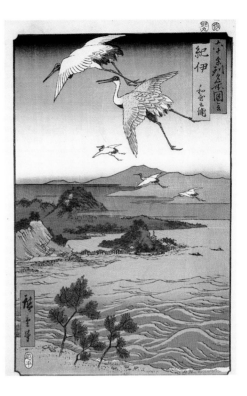

Wakanoura Bay in the Province of Kii
From the series "Famous Views of 60-Odd Provinces" (*Rokujū yoshū meisho zue*), published by Koshimuraya Heisuke, 1855
Colour print, ōban, 34.5 x 23 cm (13.6 x 9 in.), border preserved

The Rain (i.e. the tears) *of the Courtesan Tora at Ōiso Station*
From the series "53 Stations of the Tōkaidō" (*Tōkaidō gojūsantsugi*), published by Hōeidō (Takenouchi Magohachi), 1833/34
Colour print, ōban, 23 x 35 cm (9 x 13.8 in.), border preserved

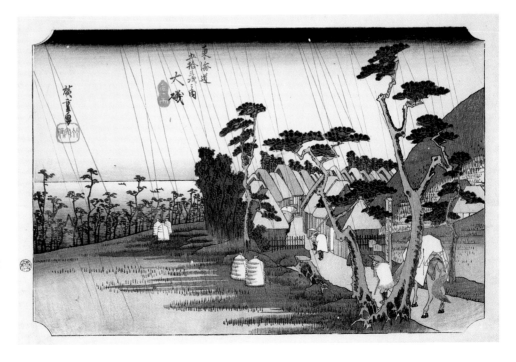

Photo credits

The publishers wish to thank the museums, private collections, archives, galleries and photographers who granted permission to reproduce works and gave support in the making of the book. In addition to the collections and museums named in the picture captions, we wish to credit the following:

All images of Hiroshige
© Chazen Museum of Art, Van Vleck Collection of Japanese Prints, University of Wisconsin-Madison;

bpk / Kunstbibliothek, Staatliche Museen zu Berlin, Photo: Dietmar Katz: p. 91 bottom right; Photograph © 1988 The Detroit Institute of Arts: p. 87 top;
Smithsonian Institution, Freer Gallery of Art, Washington (DC): p. 86 bottom.